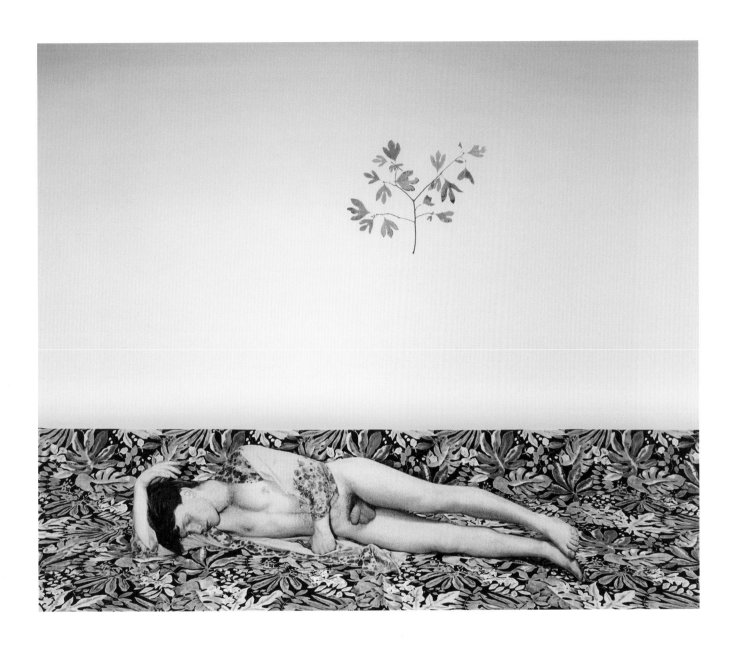

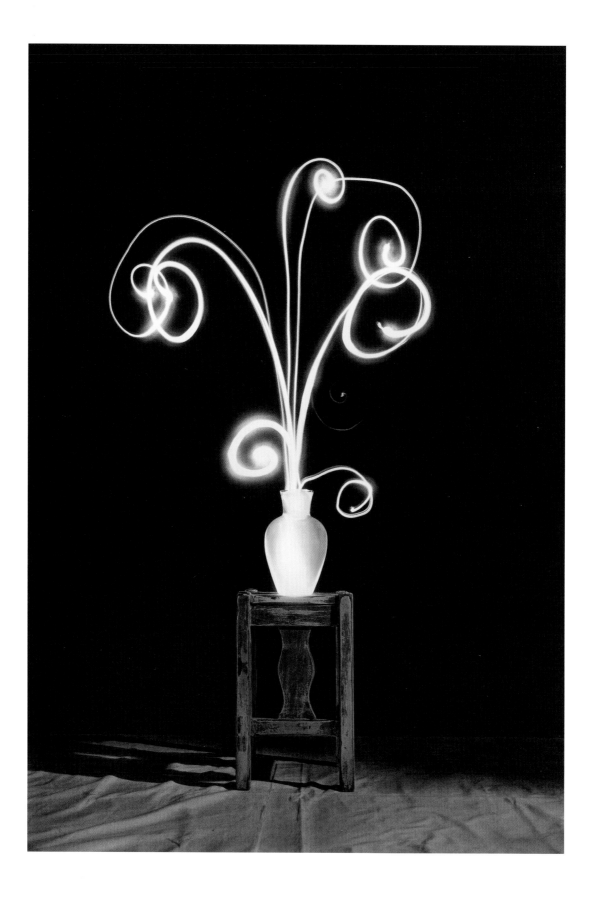

Peter Barberie

Long Light
PHOTOGRAPHS BY David Lebe

Philadelphia Museum of Art
in association with
Yale University Press, New Haven and London

Contents

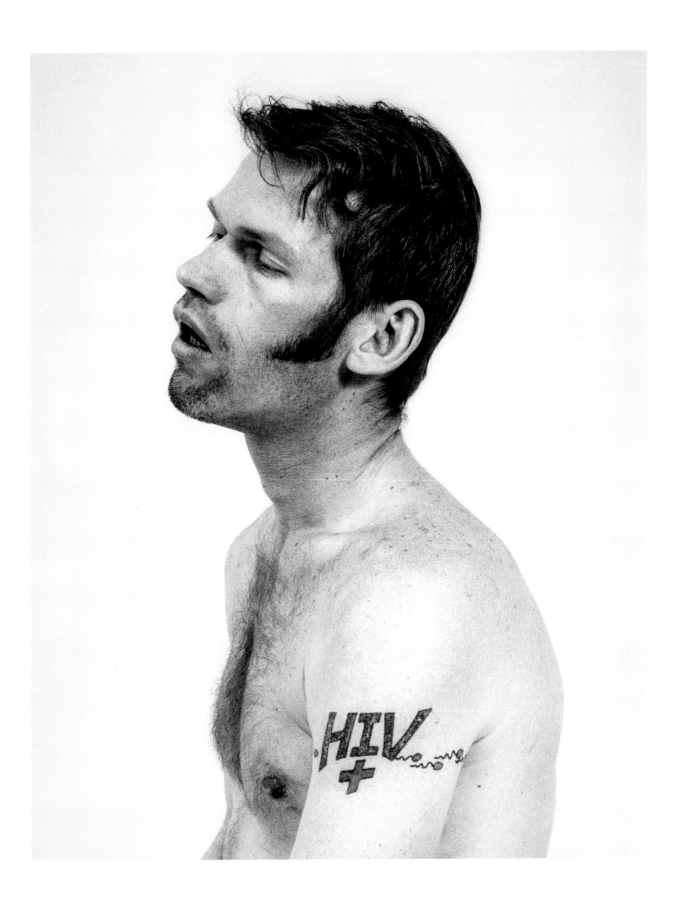

Foreword

It is a privilege to have this opportunity to share David Lebe's work with the public—a long-overdue act of recognition for an artist who studied at the Philadelphia College of Art and came of age here—and, by doing so, to acknowledge all he has achieved during a life devoted to the art and practice of photography. In this endeavor we are grateful, first and foremost, to the artist, both for his thoughtful cooperation in the development of this exhibition and for his generosity in donating a significant body of his work to the Philadelphia Museum of Art.

Second, our thanks are due to Peter Barberie, the Brodsky Curator of Photographs, Alfred Stieglitz Center at the Philadelphia Museum of Art, for engaging with the artist and presenting Lebe's remarkable accomplishments to a wider audience. While noteworthy in and of itself, this is also part of a larger project Barberie has pursued during his tenure here: to illuminate facets of the history of photography in Philadelphia, which has played an important but underappreciated role in the development of the medium in the United States. In this enterprise, his curiosity about the field has been conjoined with an advocacy for the work of artists whose vision and technical accomplishments have not yet received the attention they deserve.

In David Lebe he has found an admirable subject. Lebe's innovative use of pinhole photography and sensitively crafted images created through light drawing are emblematic of the experimental spirit of the new generation of photographers who emerged during the 1970s and 1980s—a period of dramatic technological and social change—and who boldly challenged conventions and crossed established boundaries. At the same time, Lebe's photographs reflect his understanding of the medium's potential to serve as a record of one's own life and times. For a gay man who came of age in an era that was full of promise as well as peril, this was a courageous and, in retrospect, brilliant choice.

I am delighted to express our thanks to the several donors who generously supported this project. The exhibition that this catalogue accompanies was made possible by Lynne and Harold Honickman, The Edna W. Andrade Fund of the Philadelphia Foundation, Barbara B. and Theodore R. Aronson, Emily and Mike Cavanagh, Arthur M. Kaplan and R. Duane Perry, and Lois and Julian Brodsky. We are deeply grateful for their help.

It is also a pleasure to give credit to the many members of our staff who contributed to the realization of both the catalogue and the exhibition, and who are listed in Peter's acknowledgments. We are indebted to them for the intelligence and spirit of collaboration they brought to this project.

Timothy Rub
The George D. Widener Director and Chief Executive Officer

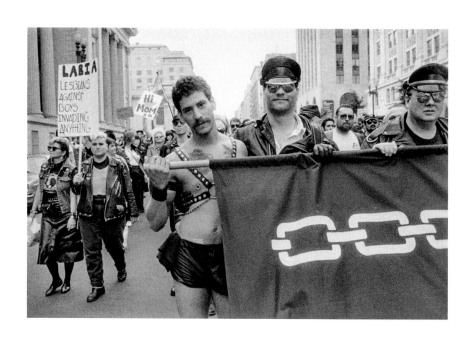

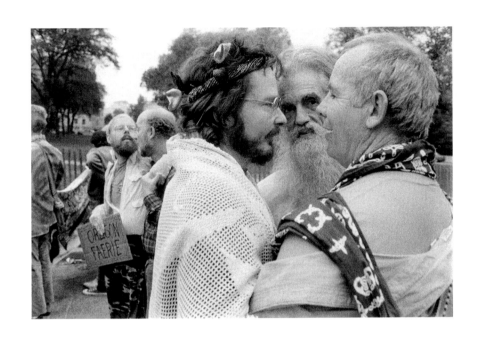

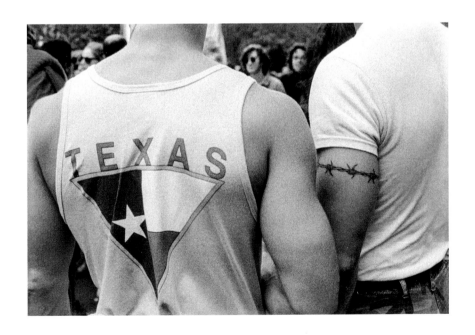

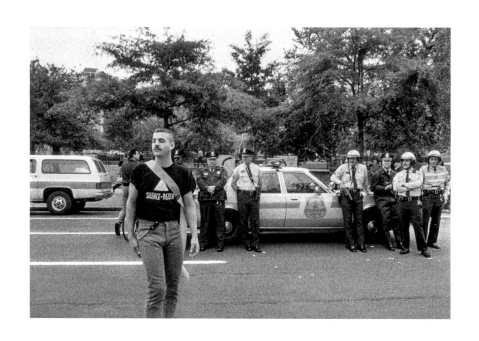

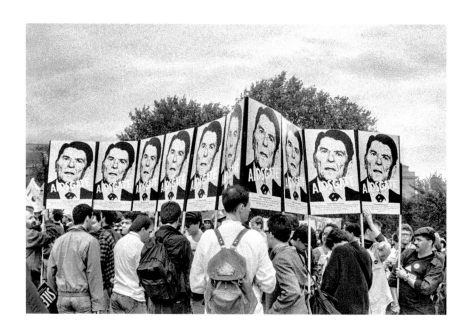

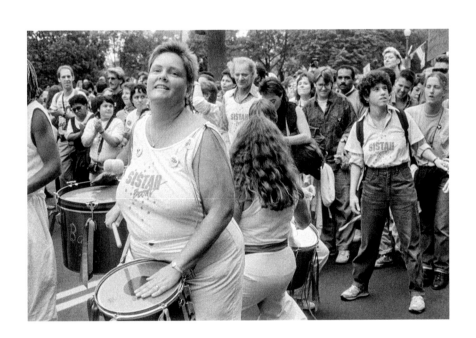

Peter Barberie

Long Light

In October 1987, David Lebe traveled with friends to the Second National March on Washington for Lesbian and Gay Rights. Neither a journalist nor a devoted street photographer, he was hesitant about bringing his camera. But he was excited about the event and remembers feeling that he must document it. Always experimental with photography, he made a last-minute decision to bring high-speed recording film, designed for surveillance work and photojournalism, knowing it would produce pictures with lots of grain. He was curious to see the effects.

Lebe's pictures from the march show a wide array of queer people and their loved ones: lesbian separatists, Radical Faeries, college kids, S/M-Leather dykes and fags (self-identified), yuppie professionals in crisp weekend outfits, and many other groups. He photographed friends as well. The writer Jane Futcher and her father hold signs that Lebe helped make (fig. 1). Political activists Larry Gross and Scott Tucker—International Mister Leather in 1986—lean into each other for a kiss on the cheek while another male couple kisses in the background (fig. 2). The graininess of Lebe's pictures suggests newspaper photographs, conferring an all-over quality that equalizes the figures and their settings; it somehow makes the photographs less about individuals and more about the entirety of the event.

More than 200,000 protesters from across the United States assembled in the nation's capital that Columbus Day weekend, from committed activists to people who had never marched for anything before. Although it was the second lesbian and gay march on Washington (the first was in 1979), it was the first one made in the grip of the AIDS epidemic, giving the event tremendous urgency. Another issue loomed that day: the 1986 Supreme Court decision in *Bowers v. Hardwick*, which upheld a Georgia law that criminalized sodomy and oral sex in the privacy of one's home, effectively authorizing persecution of gay and lesbian citizens. Yet somehow, despite the intense political context of the event and the grim, unfolding catastrophe of AIDS, the marchers gathered with defiance, exuberance, and joy. The day's official theme—"For Love and For Life, We're Not Going

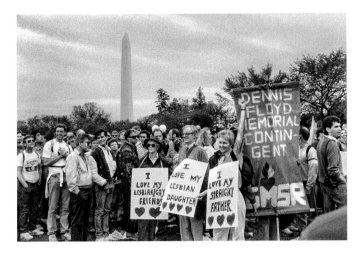

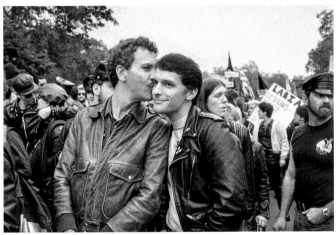

Back!"—highlighted the new and widespread sense among the queer community of a coalescing national movement and bespoke a loud refusal to return to the closet and the shadows of American life.[1]

Lebe was pleased with his photographs from the march yet unsure what to do with them. He had imagined printing them at a large scale but decided that wouldn't work. Ultimately he made a set of small prints that he neither exhibited nor published. Instead, he assembled them in an album and added informational captions to some. The modesty of that action is telling, as is his careful arrangement of the prints. Much of Lebe's photography is remarkably personal, and his working method is intuitive and slow; that is true even of these documentary street pictures, a relative anomaly in his work. He photographs the people, places, and events of his life, and when pleased with a picture he typically returns to it more than once over the course of years, often making new and different prints each time. He returned to the 1987 Washington photographs in 2018 and finally made exhibition prints of them, excited with the possibilities opened up by digital printing. He enlarged the images slightly from the first prints, matching them in scale with two later and much different series, *Morning Ritual* (1994) and *Jack's Garden* (1996–97).

In the context of this book, the first extensive survey of Lebe's career, his photographs of the 1987 March on Washington surprisingly emerge as a lynchpin to his work. Made in the uncontrolled atmosphere of a mass demonstration, they highlight his keen attention to composition. They also reveal his knowledge of street photography, which, though ancillary within his practice, was formative to his engagement with the art of photography. Most importantly, they manifest the quiet activism that has always been at the core of his art: an insistent openness about himself and his life that includes his homosexuality and gay relationships as well as his many other friendships. Finally, these photographs are, among other things, documents of the AIDS crisis. Lebe discovered he had AIDS soon after the march. Over the decade that followed he produced diverse photographs that grapple with the disease and its impact, and which together form a crucial part of his artistic achievement.

Today Lebe is best known for his experimental photographs from the 1970s and 1980s. He methodically explored rudimentary ways of making images, notably with pinhole cameras and then photograms, which require no camera at all. He also opened the aperture on his conventional cameras for long exposures while he drew or outlined with a handheld light. He hand colored many prints from these series, another elementary approach that reflects his interest in painting

Fig. 1. David Lebe. *DC87 21* [California Contingent: Jane Futcher with her father, Palmer Futcher, and their friend Polly Roosevelt], 1987 (negative), 2018 (print). Pigment print, 5½ × 8¼ inches (14 × 21 cm). Courtesy of the artist

Fig. 2. David Lebe. *DC87 17* [S/M–Leather Contingent: Larry Gross and Scott Tucker], 1987 (negative), 2018 (print). Pigment print, 5½ × 8¼ inches (14 × 21 cm). Courtesy of the artist

and that further liberated him from photography's established role as a window onto the world.

The title of this book, *Long Light*, is somewhat obscure. The phrase most often refers to the quality of daylight in late afternoon or at sunset. It aptly describes David Lebe's art because it alludes to the way he slowed down his experimental images, which involve extended interaction with his subjects and often long exposure times. It also reflects his tendency to return to earlier pictures and rework them over time. Finally, he has made moving and beautiful artworks for many decades and is only now receiving broader attention at age seventy, a most welcome "long light."[2] A little while after the March on Washington, Lebe met the love of his life, Jack Potter, who also has AIDS. In 1993 they moved to New York's Hudson Valley, planning to live out whatever time they had left in a healthy natural environment. Jack came very close to dying, and David also declined, but amazingly they rallied with the new drug combinations that became available after 1995. Today, despite myriad physical challenges, they are alive and engaged with the world, marking a poignant victory over the disease that ravaged their generation.

Generations of young LGBTQ people have migrated to New York City to find a community and make their lives. Paradoxically, David Lebe had to move away from the city for the same reasons. Philadelphia would become his gay hometown (fig. 3).

Born in New York in 1948, Lebe was adopted as the only child of quietly affluent parents, Edith and Harold Lebe, and raised in Lower Manhattan. From kindergarten through eighth grade he attended the progressive City and Country School in Greenwich Village, which proved to be formative in the best possible ways. Then as now, the curriculum at City and Country emphasized creative play, learning through hands-on experience, and ample time for intellectual exploration. Among the objectives is for each student to discover his or her strengths as an individual and as a member of a group.[3] Lebe's education there helped prepare him for a lifetime of working independently and fostered trust in his own imaginative processes.

In conversation, he recalls his years at City and Country much more vividly than his subsequent time at the High School of Music and Art in Harlem, where he was an indifferent student. Yet during high school he benefited from Manhattan's cultural offerings. Having found his interest in photography by age fifteen, he eagerly visited exhibitions at the Museum of Modern Art. He remembers his excitement over the 1966 Dorothea Lange retrospective, where he was impressed both by Lange's sensitive vision and by the elegant presentation of her prints.[4] He also avidly collected photography books. "In those days the MoMA store was quite small," he recalls. "There was one little section of photo books and I thought well, maybe over time I can buy them all. I would just pore over my books." He so loved Robert Frank's *The Americans* (1958) that he memorized every image, including their order in the book. At one point he received a MoMA membership for his birthday, which permitted him to visit the photography department to look

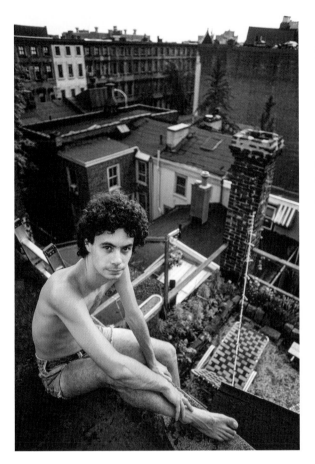

through boxes, something he did multiple times. After enrolling at the Philadelphia College of Art (PCA) in the fall of 1966, he frequently returned home and continued to absorb the city's offerings.

Few colleges had options for studying photography in the mid-1960s. Lebe chose PCA as a way to leave home yet still be near New York. To his surprise, he arrived knowing considerably more about photographic artists than his fellow students, who were mostly unaware of the figures he had discovered. When Robert Frank visited the school during Lebe's sophomore year, Lebe surprised everyone with his detailed questions about *The Americans*. But he had not encountered the photography of other artists such as László Moholy-Nagy and Man Ray. His education at PCA would change that.

During the 1960s, Philadelphia, long home to a number of prominent art schools, saw an influx of remarkable photographic talent from a handful of graduate programs throughout the country. One such program was Chicago's Institute of Design (ID), founded by Moholy-Nagy based on teaching principles he had helped develop in the 1920s at Germany's Bauhaus. Moholy-Nagy's approach came to underpin much visual arts education in the United States, including at PCA, where department chair Sol Mednick recruited ID graduates Ray K. Metzker and Tom Porett to the faculty, later to be joined by another ID alumna, Barbara Blondeau. All three artists encouraged broad experimentation at every stage of the photographic process, from the camera to the darkroom to the final presentation of work.[5]

Lebe and other PCA alumni recall Metzker as a generous and impactful teacher, though Lebe's earliest interaction with him was not auspicious.[6] During Robert Frank's aforementioned visit and lecture, Metzker had questioned Frank in a way that seemed critical of his composition and printing (both tightly controlled elements in Metzker's work). Lebe was upset by what he perceived as Metzker's disapproval of Frank's relaxed approach to craftsmanship, which Lebe thought entirely missed the point of Frank's work. But the following fall, during his junior year, Metzker won him over. "The thing with Ray's teaching for me, I never had to take a note," Lebe recalls. "He was very clear, and I always felt he was telling me things that I already knew but had not been able to articulate." Metzker would speak in detail about students' prints, frequently citing his ID teachers Harry Callahan and Aaron Siskind, as well as Moholy-Nagy. "He talked about how to deconstruct a photograph, analyze it . . . how a photograph works in a formal way, in its architecture and structure. Once you can talk about it then you can see it. Once you see the structure you can build it yourself. That was a true gift, and Ray gave it to me in a form that was useful." Lebe notes that Metzker never talked about subjects or content: "nothing emotional, personal, or sexual; he always stuck to questions of form."

Fig. 3. Terry Hourigan (American, born 1948). *David Lebe on His Roof, Philadelphia*, August 1977. 35mm Kodachrome. Courtesy of David Lebe

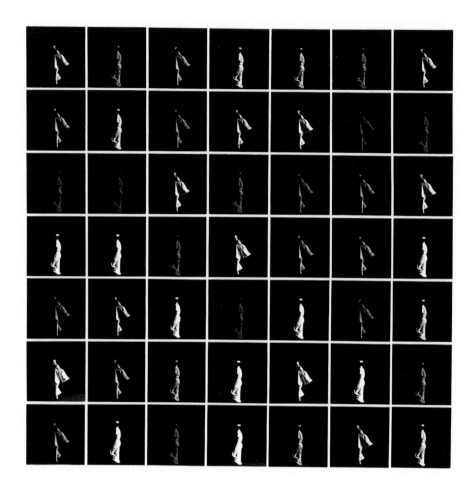

Metzker frequently exhibited and published his photographs, including a solo exhibition at MoMA in the fall of 1967, so Lebe was familiar with his work before studying with him. Its emotional distance struck Lebe early on, but he also appreciated its playfulness. Many of Metzker's subjects, such as the solitary figure in *Composites: Sailors, Philadelphia* (fig. 4), resonated with him. The work is an assemblage of forty-nine prints, in varying tones, made from just two negatives. Both images depict a sailor Metzker observed walking among the arcades of Philadelphia's City Hall. It certainly adopts a cool stance toward its subject, and its formal structure is arguably more striking than its content. Yet as with much of Metzker's street photography, his regard for his subject is not ironic but engaged and attentive. The result is a thrilling, mysterious depiction of urban solitude.

For Lebe's senior thesis with Metzker he produced a series of photographs he titled *Form without Substance*, comprising images of shadows in the cityscape and other subjects whose forms are distorted or dissolved through blurred focus, montage, and other means. It is an accomplished thesis, but hews closely to Metzker's and Blondeau's approaches (fig. 5). A related photograph from this period, *Moratorium Day Kiss* (fig. 6), better reflects Lebe's own sensibility: while also featuring shadows,

Fig. 4. Ray K. Metzker (American, 1931–2014). *Composites: Sailors, Philadelphia*, 1964. Gelatin silver prints, 12¾ × 12¹³⁄₁₆ inches (32.4 × 32.6 cm). Philadelphia Museum of Art. Purchased with the Contemporary Photography Exhibition Fund, the Alfred Stieglitz Center Restricted Fund, and the Alice Newton Osborn Fund, 1977-73-3

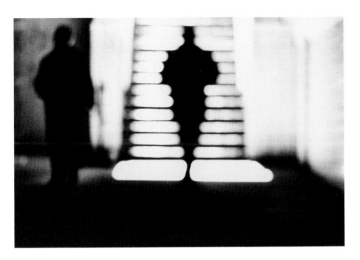

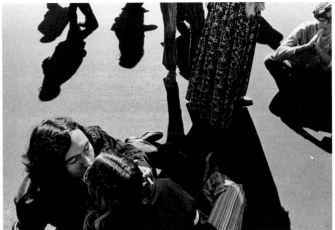

its primary subject is an act of public affection as protest, anticipating his photographs of the March on Washington eighteen years later.[7] The Moratorium to End the War in Vietnam, held October 15, 1969, was a nationwide day of marches and teach-ins on college campuses and in large cities. Blondeau also photographed in Philadelphia that day, making experimental pictures with high-contrast orthochromatic film, which she printed on transparent film sheets, selectively applying acrylic—including spray paints—to further alter the scene (fig. 7). Her tableau of young protesters walking with a dog (age-old symbol of fidelity and companionship), each marcher's expression accentuated by acrylic additions, presents a forceful image of generational dissent and questioning.

Blondeau, a private, introspective person in both her life and her art, was just as important a mentor to Lebe as was Metzker. "As a teacher Barbara was the total opposite of Ray," Lebe says. "She was very quiet. But I found her very supportive. Just being around her made me feel good."[8] Lebe took a single class with her in his senior year. It proved formative not only because of her teaching approach but also because it led to their friendship. Blondeau would ultimately hire Lebe to return to PCA as an instructor a few years after he left school, thus helping him set his longer course as an artist. She was also closeted about her same-sex relationships, an aspect of her life that Lebe later understood and which profoundly affected him.

In Lebe's memory, Blondeau's class was called "Alternative Materials" and consisted of one assignment each week tackling a different process or technical challenge. Among the early assignments was pinhole photography, a rudimentary process using a camera but no lens, which requires long exposures yet offers infinite depth of field and much opportunity for creative intervention. Lebe built a pinhole camera (part of the assignment) and quickly became enamored with both the object and the pictures it could make. He spent the rest of that semester making pinhole pictures, a direction that both Blondeau and Metzker endorsed. He would continue exploring the process for five years, producing his first distinctive body of photographs.

17

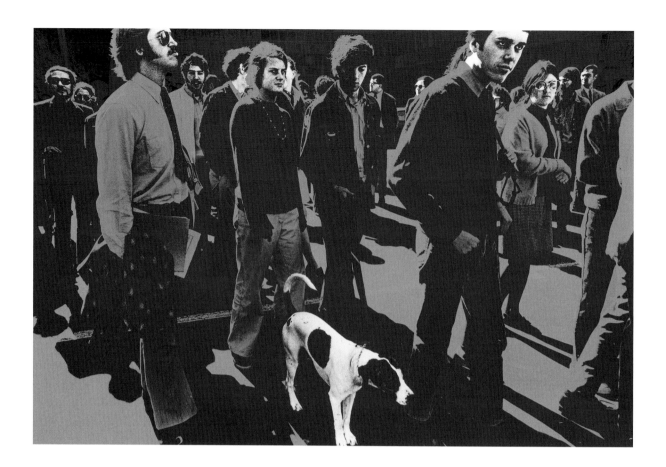

Fig. 7. Barbara Blondeau (American, 1938–1974). *October 15*, 1969 (negative), 1969–74 (print). Orthochromatic film positive with acrylic paint, 14 × 20⅛ inches (35.5 × 51 cm). Philadelphia Museum of Art. Purchased with the Julius Bloch Fund Created by Benjamin D. Bernstein, 2018-94-1

Lebe ultimately built several pinhole cameras with multiple apertures, pleased with how the multipart structure permitted him to break the picture plane and scramble the experience of time. *Self-Portrait with Flag* is one of his early efforts made for Blondeau's class (fig. 8). He opened every aperture to record the scene simultaneously at different points within the semi-circular chamber. While its content brushes up against Lebe's protest pictures and nods to examples by Frank and others that grapple with the flag, what excited him most about photographs such as this was the process and the opportunity to involve himself. In 1994 he explained this to Richard Kagan, comparing pinhole to 35-millimeter photography:

> Instead of scanning [with the camera], I was working intuitively within parameters I had set up. . . . I also was able to walk around and get into the picture and that was, I thought, a lot of fun. Instead of being a "decisive moment," the photograph became the decisive 20 minutes. . . . I learned that a photograph wasn't necessarily an instant but could be a longer length of time, could be a whole event.[9]

Pinhole's low-tech adaptability also allowed Lebe to make pictures that would have been impossible with more advanced equipment, such as an expansive self-portrait

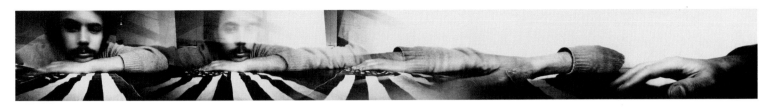

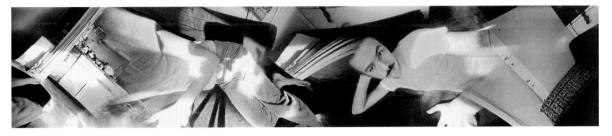

in his tiny Philadelphia apartment (fig. 9). In time Lebe built a nine-aperture camera that produced delightfully unwieldy pictures, including group portraits he made of fellow artists, such as *Seven Photographers Seventy-Five* (see plate 5). It depicts (from left to right) Laurence Bach, Ron Walker, Judith Harold-Steinhauser, Howard Bossen, Joan Redmond, and Bruce Lewis, all members of the Philadelphia photo scene.

The stop-and-start, slowed-down pace of pinhole work provided Lebe with precisely the structure he liked for making street photographs. He explored Philadelphia with a four-aperture camera that he could use in the field, sometimes bringing models along but just as frequently encountering people who agreed to pose for him (fig. 10). A photograph his friend Susan Welchman made of him using the camera in 1974, behind the Philadelphia Museum of Art, nicely captures his approach (fig. 11). Lebe observes that before he discovered pinhole, he often felt that the technology of traditional cameras came between himself and his subjects. By approaching every photograph as an "event" that involved him and his sitters in the curious, drawn-out process of setting the scene, posing, and interacting with each other, he turned photographing in public into a social activity.

Among Lebe's friends, Welchman became his most frequent model. A PCA classmate he reconnected with a few years after graduation, she had a quirky fashion sense that Lebe loved. "I had clothes that were my mother's," recalls Welchman, "things she had gotten from rummage sales and from a friend who was an opera singer on the radio. I loved to dress up. I remember trying lots of things on in the morning before I'd decide what to wear."[10] She also remembers Lebe's offbeat aesthetic sense, evidenced in those days by his flowery shirts and carefully arranged apartment. His photographs of her are among his most engaging pinhole pictures: he would scope out empty areas of the city, including rooftops and parking lots, where they could play with poses and setups (see plates 2, 4). Working with Welchman was his first experience of real collaboration with a model, a give-and-take process he came to value highly from that point forward.

Fig. 8. David Lebe. *Self-Portrait with Flag,* 1970. Gelatin silver print, 2⅜ × 23 inches (6 × 58.4 cm). Philadelphia Museum of Art. Gift of the artist, 2016-30-19

Fig. 9. David Lebe. *At Home: Self, Philadelphia,* 1973. Hand-colored gelatin silver print, 2⁵⁄₁₆ × 12¹⁄₁₆ inches (5.9 × 30.7 cm). Courtesy of the artist

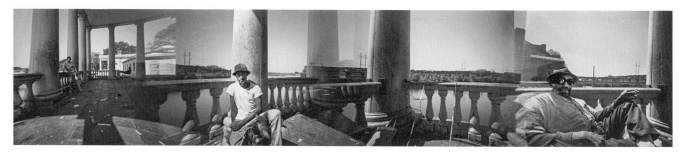

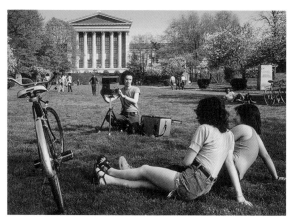

Fig. 10. David Lebe. *Fishing at the Water Works, Philadelphia*, 1973 (color transparency), 2015 (print). Pigment print, 4 × 19⁹⁄₁₆ inches (10.2 × 49.7 cm). Philadelphia Museum of Art. Gift of the artist, 2017-144-23

Fig. 11. Susan Welchman (American, born 1947). *David Lebe Using His 4-Pinhole Camera behind the Philadelphia Museum of Art*, 1973–74 (color transparency), 2016 (print). Pigment print, 4 × 5¹¹⁄₁₆ inches (10.1 × 14.4 cm). Collection of the Philadelphia Museum of Art

In 1973 Lebe began using Ektachrome film for some of his pinhole pictures. He regularly shot with color slide film around the city, and he wanted to bring color into his work. Over the next few years he made strong color pinhole images, including a tender portrait of Blondeau and himself (fig. 12). He experimented with exhibiting them illuminated by light boxes, but was ultimately frustrated by their display limitations. Moreover, he found color prints unattractive and did not like the loss of darkroom control the process entailed in comparison to black-and-white prints. One day he was surprised to come upon an old-fashioned hand-coloring set in a New York City camera store. He purchased it on impulse, opening up an important new aspect of his work.

Photographs have been hand colored since the 1840s, soon after the medium's invention. But such adornment was usually the purview of commercial studios or amateurs. In the twentieth century, as photography gained in artistic stature, serious practitioners avoided it altogether or dabbled in a strictly minor way. Numerous photographers of Lebe's generation experimented with hand coloring—paralleling several others who pioneered serious color film photography—but few pursued it with Lebe's commitment and inventiveness. He painted nearly all of his pinhole pictures of Welchman, choosing colors that bore no relation to what her clothes actually looked like, but instead reflected his own sensibility.[11]

During the period that Lebe explored pinhole photography he also came to terms with his homosexuality, and in time celebrated it. Lebe came of age at the moment of awakening queer resistance in American society. In 1965, the year before he began studies at PCA, the East Coast Homophile Organizations (ECHO) came together for their first Annual Reminder, a non-confrontational picketing event held on July 4 in front of Philadelphia's Independence Hall. Well-dressed participants carried signs with messages such as "Homosexuals should be judged as individuals." The Annual Reminders took place through 1969, when the Stonewall rebellion in New York prompted ECHO to turn its energies toward helping launch the first New York City Pride Parade in 1970. Lebe remembers hearing about the Annual Reminder while at PCA and being fascinated and terrified that anyone would publicly proclaim their homosexuality. PCA was a supportive environment, but at that time even art school was not a safe context for coming out of the closet.

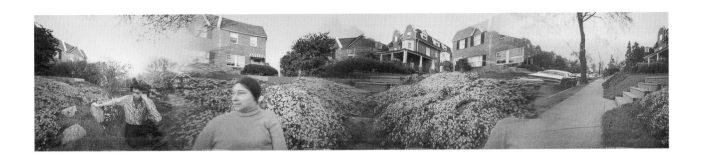

Fig. 12. David Lebe. *BB & Me,
Germantown*, 1974 (color transparency),
2016 (print). Pigment print, 4 ×
19 ³⁄₁₆ inches (10.1 × 48.7 cm).
Philadelphia Museum of Art. Gift
of the artist, 2017-144-6

Although American society was on the cusp of a radical transformation in
public attitudes about sexuality, the change on the horizon was often impossible to
see. Richard Kagan, who much later would apprentice with Lebe and also publish
an important interview with him, recounts the homophobia he encountered at
Temple University in the early 1960s as a member of the Congress of Racial
Equality (CORE). One of Kagan's political mentors told him how disappointed
he was to learn that Bayard Rustin and David McReynolds—national figures in
the civil rights and antiwar movements and heroes to Kagan—were homosexual.
Kagan recalls, "It was beyond any acceptable behavior."[12]

Lebe would not confront his own sexual identity until after school in 1970.
That summer he became severely depressed and, contemplating suicide, sought help.
Upon his first visit to a counselor he came out to her, initiating an effort to come
to terms with his feelings. After several sessions, Lebe's counselor referred him to
a male colleague, an analyst whom he disliked. Nevertheless, he would remain in
analysis for about a year. At one point the analyst suggested that he bring in some
of his photography, and Lebe chose his senior thesis project, *Form without Substance*.
Looking at those abstracted photographs in the context of his therapy, he under-
stood that they revealed aspects of his emotional and psychological turmoil, almost
literally illustrating the secrets and absences in his life. He found this disturbing
but also gained some genuine understanding about artistic process: "To suddenly
see that these pictures made in the context of Ray's teaching were also about my
emotions and experiences . . . gave me the confidence that if I just worked intently
there could be meaning in my pictures without me knowing it in the moment."[13]

Following his therapy, Lebe did not immediately come out to anyone else.
Instead, he began building a life in Philadelphia, where he'd decided to stay in part
because he felt it would be impossible to live as a gay man among family and
friends in New York. His parents, while politically and socially progressive, were
nonetheless personally conservative and wanted conventional stability for them-
selves and their son. Lebe would not come out to them until 1980, and they would
be slow to accept his decision to live an openly gay life.

In 1973 Lebe came out to a handful of friends, including Jane Futcher.
She remembers that when he said he had something important to tell her, she was
afraid he was going to profess a romantic interest in her. Instead he said he was gay,
and she promptly told him that she was, too. They celebrated by making a portrait

of Futcher in front of a straight bar called "Gay Nineties," whose sign advertised the go-go dancers inside with a cartoonish image of a buxom lady (see plate 9). Lebe recounts the significance of the photograph at the time: "Jane was the second person I came out to, and I was one of the first people she came out to. When I made that pinhole photo there was a newness, an excitement, a daring, a kind of exhilaration about it. About everything, really. The world felt like a new place for a moment. Jane was more politically savvy than I was then and helped me see the world clearer, especially when it came to sexual and gender politics."[14] The moment was equally important to Futcher. "I think we really helped each other," she says. "David was a working artist and I wanted to be a writer, but I didn't really know how to do it. Here he was, absolutely committed to photography and to experimenting with pinhole and then light drawing. He was totally brave about doing what he wanted to do. That was inspiring to me."[15]

The following year, Lebe photographed himself near a statue of two nude wrestlers in Fairmount Park, outside Philadelphia's Memorial Hall (see plate 3). He winked in the picture as a sort of coded gay message, and he still considers it one of his first acts of coming out. From that point forward he would slowly incorporate gay content more and more explicitly into his art. This is one of Lebe's most delicately hand colored pinhole photographs. He made the picture in late afternoon in winter or early spring, as evidenced by the long shadows cast by him and the camera, and by the orange-pink glow of the setting sun, which he emphasized dramatically. One fascinating aspect of any painted photograph is the way the painter navigates detail. There are always more details than one can imagine, and in highly finished pictures such as this, the artist's meticulous, quiet attention feels almost like an act of love.

By 1974 Lebe began to explore beyond pinhole photography, which he would soon stop making altogether. Desiring to work at a larger scale and to master hand coloring, he turned to making straightforward portraits of neighbors and friends, often choosing detailed settings that presented real challenges to painting. Conscious that he was veering away from trends in serious photography, he dubbed these pictures *Unphotographs* (see plates 11, 12, 14). *Susan on Shelf*, a unique three-dimensional object from the same moment, must be counted among them though not officially part of the series (see plate 10). Obviously stemming from his pinhole collaborations with Welchman, it is a joyful image of her personality and their friendship, the purple shade of her dress virtually bouncing off the painted orange shelf behind.

Most of the *Unphotographs* feature subjects who were Lebe's friends to one degree or another, including other Philadelphia artists. Because painting them was so laborious, he made fewer than a dozen, and the series as a whole feels at once both highly accomplished and tentative. As portraits, they capture the newly emerging social mores of the 1970s, including the same-sex couples who were increasingly visible in Lebe's neighborhood. One of the most engaging examples is a self-portrait he made with Joan Redmond, who would become a close friend over the next few years (see plate 14). Posed near the boardwalk in Atlantic City, the ambiguous pair (are they a couple?) loom over the horizon with half-smiles

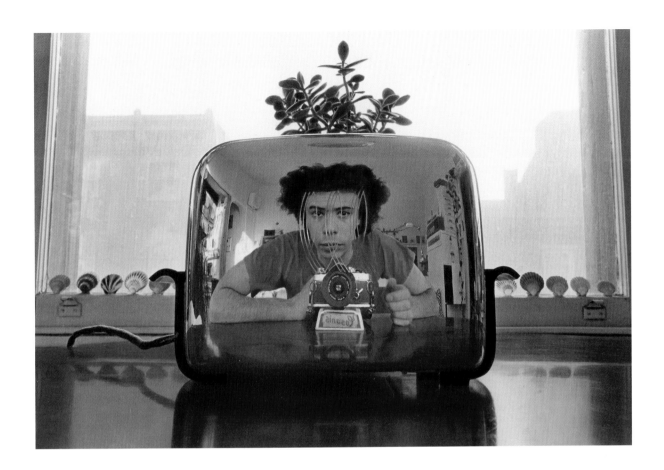

Fig. 13. David Lebe. *Unphotograph Seven—Self-Portrait in Toaster*, January 4, 1975 (negative), c. 1975 (print). Hand-colored gelatin silver print, 6⅜ × 9⁵⁄₁₆ inches (16.1 × 23.6 cm). Philadelphia Museum of Art. Gift of the artist, 2016-30-9

and disarming self-assurance, almost like a modern-day Hera and Zeus. In palette they seem to be from a bygone era, like a souvenir postcard from earlier in the century. But the billboard for Marlboro cigarettes in the distance, with the familiar cowboy looming over his own horizon in his romanticized landscape, pulls the viewer back to the 1970s.

Lebe's return to PCA in 1972 as an instructor had put him in new relationships with his former teachers. He saw Blondeau at social gatherings and eventually realized that she dated women. However, she was firmly closeted about her relationships. By then she was battling breast cancer, which would take her life at the end of 1974. In the weeks before her death, Lebe came out to mutual friends. He hoped that he and Blondeau would discuss their sexuality, but neither of them brought it up during his visits with her in the hospital. Blondeau died on Christmas Eve. This was Lebe's first experience losing a close friend. Not knowing what else to do, he retreated to his apartment and cleaned. He began polishing his toaster (something he had never done before), and at some point realized that he had polished it to sparkling perfection. Some days later he used it to make another *Unphotograph*, a reflective self-portrait that shows much of his well-ordered apartment and gives a sense of the aesthetic sensibility that pervades his life (fig. 13). In its clarity, the picture appears as a moment of candid personal reckoning. Blondeau's death

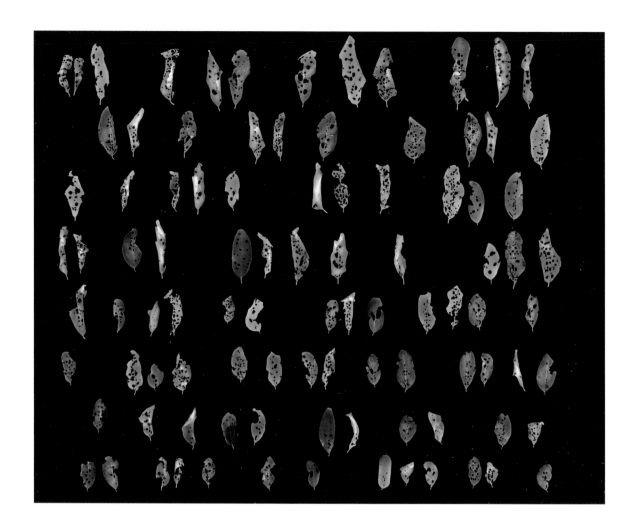

and her inability to come out crystallized a central fact for Lebe: he did not want divisions between his life and art, or barriers around his most personal feelings.

In 1975–76, Lebe, Redmond, and Ron Walker, another colleague from PCA, organized Blondeau's archive and deposited it with the Visual Studies Workshop in Rochester, New York, where the founding director, Nathan Lyons, had been a supporter of her work. They also curated an exhibition and published a slim, elegant catalogue.[16] This process constituted Lebe's first real encounter with much of Blondeau's photography, which she rarely exhibited or published in her lifetime. In 1994 he explained to Kagan that this experience influenced subsequent directions in his work. "Barbara had used a wonderful variety of playful techniques and she often combined them with implications of death. Almost immediately, and for the next year and a half, I began searching and experimenting with different forms—handcoloring, photograms, light drawings."[17]

In fact, Lebe's experiments were quite different from Blondeau's, but he was clearly inspired by her open-minded curiosity about the ways and means of photography. His observation that themes of death recur in her work points to

Fig. 14. Barbara Blondeau. Untitled, 1971. Gelatin silver print, 15⅞ × 19¹¹⁄₁₆ inches (40.3 × 50.4 cm). Philadelphia Museum of Art. Purchased with the Julius Bloch Fund Created by Benjamin D. Bernstein, 2018-94-3

important shared ground between the artists. We see it in a stunning photogram by Blondeau of small, decayed leaves (fig. 14). She made at least two pictures with these leaves: in the other example she lined them up in eight neat rows, a precise and almost humorous rationalization of natural, unpredictable things. Here she organized them in similar rows but removed many and turned others over, animating each one and highlighting the differences from one to another. The random gaps between these fragile objects serve to emphasize their ephemerality.

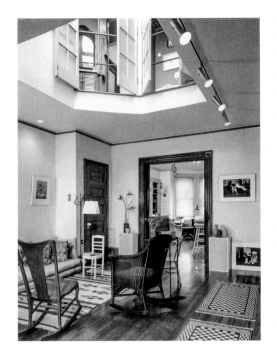

Lebe purchased his first home in 1976, a large 1880s townhouse on South Fifteenth Street in Philadelphia. The building was divided into apartments but still had ample space for his living quarters plus a darkroom and studio. In the coming years he would produce complex series that required the freedom and new work spaces this house provided. It also became an extension of his art. As Kagan observed, entering Lebe's home is a bit like entering one of his photographs: rooms are carefully arranged, color punctuates each space, and objects from his pictures are to be found everywhere. Many of his friends mention the Fifteenth Street house as a special place (fig. 15).[18] The artist Seth Eisen, who worked for Lebe as a student and became a frequent model (see, e.g., page 1; plate 49), recalls: "We would sit countless hours drinking coffee or tea. Everything was meticulously arranged. . . . David would float around the kitchen. He would cut a tomato and it was the most beautiful thing."[19]

Lebe's life expanded with his new home. In 1977 one of his first apartment tenants was the artist Barbara Crane, who became another friend and creative interlocutor. She was in Philadelphia for a one-year teaching appointment at PCA, but the two had met years earlier in Chicago at a gathering hosted by Aaron Siskind. Lebe recalls that Crane was the only woman present then. In Philadelphia, they quickly grew close and found that they could talk freely. Crane opened his eyes to the sexism in academia and the desire of women photography students to have more women teachers.[20] Her artistic practice also resonated with directions Lebe's photography was taking. In works such as *City Lights*, Crane combined her experimental approach with content about sexual desire (fig. 16).

Before leaving his apartment in 1976, Lebe had begun a new line of experimentation that proved fruitful. Home alone one evening, he opened his camera shutter and began drawing with a flashlight, ultimately outlining his own nude figure with light. His first efforts were enthralling if somewhat crude, due to his lack of experience manipulating the light (fig. 17). But he realized that this approach involved enough technical complexity and visual meaning for a large body of work. His desire for the male figure could now be fully incorporated into his art.

That same year he also began experimenting with photograms, which in time would become another ambitious series parallel to the light drawings. Whereas pinhole photography uses a camera but no lens, photograms dispense with the

Fig. 15. Floyd Waggaman II (American, 1923–2011). *David Lebe's Living Room and Studio, Philadelphia*, 1985. Polaroid print, 4½ × 3½ inches (11.4 × 8.9 cm). Courtesy of David Lebe

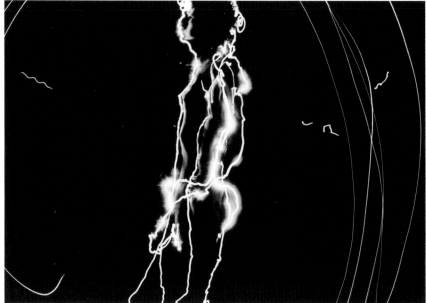

camera altogether, relying on the most direct means: objects arranged on light-sensitive paper and exposed to light. Although the process is simple, Lebe's approach to it was not. He needed space and time to harvest and dry plants, among other picture elements, then arrange and rearrange them on sheets until he found compositions he liked. Exposing the sheet resulted in a negative print with a black ground, which he often used as a finished picture. But he also made positive prints from those negatives, and sometimes then positives and negatives again, occasionally adding elements at later stages of production.

Lebe called several early photograms *Specimens*. They sometimes incorporate animal bones and inorganic elements such as lace and glass beakers (see plate 16), but there is nothing scientific about them. In a few, he assembled plant parts and bones into hybrid combinations of flora and fauna. Even at this early stage he began dissecting flowers or whole plants into their constituent parts in order to recombine them into fantastical forms. In time he focused almost exclusively on plant life, situating his creations in highly imaginative settings that he named *Gardens* and *Landscapes*.

Lebe achieved some of his most beautiful and mesmerizing hand coloring in these prints. His chosen colors, like his arrangements of plant elements, often bear no relationship to the actual appearance of the natural objects they shade. But we should not take these decorative fantasies lightly. Roots cling and push their way through imagined surfaces; stamens, pistils, and seeds dance through the atmosphere; and worlds glow with eerie light. Lebe offers up a fertile, sexy, gentle but dark universe for our delectation.

By 1979 Lebe returned to making light drawings with greater focus. He would continue them in one form or another for more than a decade. For a few years he concentrated primarily on the male figure. The process for these pictures is

Fig. 16. Barbara Crane (American, born 1928). *City Lights*, 1967 (negative), 1969 (print). Gelatin silver print, 13¾ × 10⅞ inches (34.9 × 27.6 cm). Philadelphia Museum of Art. Purchased with funds contributed by Focus: Friends of Photography, 2017-2-1

Fig. 17. David Lebe. *Self-Portrait #2*, 1976. Gelatin silver print, 9¹⁄₁₆ × 13 inches (23 × 33 cm). Courtesy of the artist

akin to that for his pinholes in two ways: it involved opening the camera aperture for an extended length of time, and it invited real collaboration between Lebe and his models. The duration of a session might be anywhere from five minutes to more than forty. Operating in near total darkness or with a minimal light source, he would methodically work his way around the figure and the room, outlining every element he wanted in the picture. With practice he learned how to modulate the light with considerable control, producing thicker or thinner lines, starbursts, and passages of glowing incandescence. Sometimes his lingering presence can be detected by the ghost of his arm or foot, as on the left side of *Angelo in Robe*, one of his most complex light drawings (see plate 20).

Other photographers experimented with light drawing before and after Lebe, but none have used it for anything like his profound examination of human touch and exchange. Many of the models were his lovers. "I was photographing what was in my life. Photographing somebody was an important thing to me. When I was having an affair with someone who wanted to be photographed, it was very satisfying."[21] However, the sensuality of these works goes beyond sexual attraction and pleasure. Light traces the contours of bodies like a loving gaze or caressing touch, and also seems to emanate from them like energy or desire made visible. In the most powerful of these pictures, it seems to be something shared between artist and subject, possessed now by one, now by the other. Bernard Welt, an art writer and friend who posed for Lebe later in the 1980s, observes, "David makes light a subject like our bodies." He recounts that the experience of posing for his light drawing—with another friend, Grady Turner—was far from erotic. The session lasted around thirty minutes, and Lebe's close proximity felt nurturing and protective (see plate 42).

Lebe is by no means the only artist of his generation who dove into the personal in order to make his art. The perils of that terrain are well-charted: solipsism, shock value, or, worst of all, the stultifying boredom of personal minutiae, making the artist, in Lebe's words, "like someone who just chatters on."[22] Photography is certainly susceptible to these dangers. Yet in sensitive hands this is where it finds some of its salient power. It is instructive to compare Lebe's photographs with those of Emmet Gowin, an artist who made deeply personal work beginning in the mid-1960s. Focusing on his wife, Edith, and their sons and extended family, Gowin let the sensuality of home life permeate his work. Gowin and Lebe were conscious of moving away from their formalist training, and both artists describe that shift not in terms of rebellion or reaction but of being pulled by subjects they found irresistible. (Gowin, a decade younger than Metzker, also studied with Harry Callahan, at the Rhode Island School of Design.) In the photograph *Edith and Rennie Booher, Danville, Virginia* (fig. 18), we are invited to share—just a little—in the sexual electricity between the young couple Emmet and Edith. We also witness the beautiful, spectral adjacency of vitality and death at home.

Whereas Lebe's turn to personal subject matter reflects a shared sensibility among his generation of artists, his extended exploration of rudimentary and even archaic aspects of photography is unique. Many of his peers looked into the

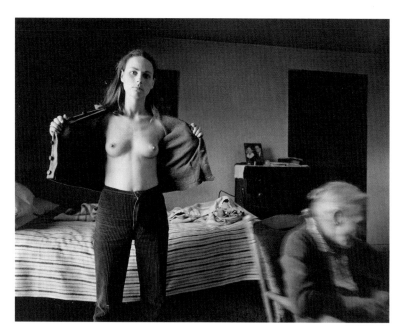

medium's history to investigate alternative processes, and that milieu formed an important context for his experiments.[23] But Lebe is singular as an artist who methodically produced a diverse body of work about contemporary life using elemental photographic means. He insists that he was uninterested in the antiquarian aspects of these approaches. Rather, he experienced the complex technology of cameras as a barrier to his subjects. So he turned to methods that were, in his words, "like drawing with a pencil."

An unlikely but important point of comparison for Lebe's work is the turn by other of his peers to working with large-format view cameras. An old-fashioned method that nonetheless relies on sophisticated optics, large-format photography requires a slowed-down, stop-and-start approach much like Lebe's efforts with pinhole photography and light drawing. It also invites similar interaction and collaboration with models. In the hands of artists such as Stephen Shore and Judith Joy Ross it became a powerful and influential means of depicting the modern world. Shore paired it with color film to produce unsettling pictures of quotidian experience. Ross used it for quiet, searching photographs of people from cross-sections of American life, often working with subjects she did not personally know to craft complex social portraits (fig. 19).

Teaching at PCA (which became University of the Arts in 1987), Lebe felt it was imperative to be open about himself and forthrightly out to colleagues and students. He devised a strategy of showing his work during the first week of class, so that students could see his life and understand it without discussion. He also thought it would help them better understand his critiques. During these years he exhibited only occasionally. That is partly a reflection of his personality: he is more engaged by making art than almost anything else, and his working process is intuitive rather than driven by exhibitions or other external projects. But even in the 1980s, venues willing to show male nudes and frankly homoerotic art were scarce. An exception was Paul Cava, a Philadelphia artist and dealer who was an early advocate and began showing Lebe's work in 1981.[24] He in turn introduced Lebe to the New York gallerist Marcuse Pfeifer, who included his work in group shows before mounting a 1986 solo exhibition, *Light Drawings and Painted Photograms*. Pfeifer, a feminist and lesbian, opened her gallery in 1976 and early on supported the work of gay photographers, including Peter Hujar and Robert Mapplethorpe. In 1978 she mounted a now legendary exhibition titled

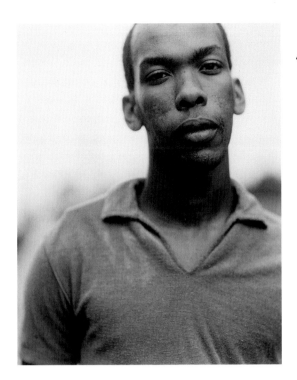

Fig. 19. Judith Joy Ross (American, born 1946). Untitled, from *Portraits at the Vietnam Veterans Memorial, Washington, D.C.*, 1984 (negative), 1985 (print). Gelatin silver print, 9⅝ × 7¾ inches (24.4 × 19.7 cm). Philadelphia Museum of Art. Purchased with funds contributed by the Friends of the Alfred Stieglitz Center, 2014-52-1

The Male Nude: A Survey in Photography. She insists that the show, controversial at the time, is today misunderstood as a gay exhibition. "I had so many women in my stable who were taking pictures of the male figure. My show was a feminist statement about nudes *not* of women and also *by* women."[25] In addition to contemporary photographers such as Judy Dater, Lynn Davis, Hujar, and Mapplethorpe, the exhibition included work dating back to Civil War medical photography as well as rare nudes by artists such as Berenice Abbott.[26]

In 1985 Lillian Liberman, a cousin of Lebe's from Mexico City, sent him a Day of the Dead postcard just weeks after the region had been devastated by terrible earthquakes. She ended her note with the words "In fact we laugh with the idea of death." Lebe made a photogram of the card and titled it with her phrase, hand coloring several of the prints (see plates 40, 41). Although his cousin's words concerned the loss of life in Mexico City, her note resonated with the AIDS crisis that was then engulfing communities around the world. Lebe, like others, had at first been reluctant to accept mainstream press reports about the disease, which referred to it by the homophobic acronym GRID (gay-related immune deficiency), as well as "gay cancer." As awareness of the epidemic increased and cultural backlash set in, the gay community grew wary not only of the media but also of the medical establishment, and felt increasingly isolated by the accusatory responses or silent indifference of political leaders.

Lebe's 1979 photograph *Barry in Rocker* depicts Barry Kohn, one of his most important love interests (see plate 17). A prominent Philadelphia attorney, Kohn was married with a young son and a close-knit extended family when Lebe met him. He and his wife, Alice Matusow, were about to publish their memoir *Barry and Alice: Portrait of a Bisexual Marriage*.[27] The ambitious press campaign for the book included appearances by Barry and Alice on the nationally syndicated talk show *Donahue* and in a public-television documentary that was filmed partly in Lebe's living room. (The documentary, produced by the PBS affiliate in Washington, DC, was scheduled for nationwide broadcast, but the other stations ultimately dropped it because of the subject matter.) Kohn was a loving, gregarious, chaotic figure. With his encouragement, Lebe came out to his parents, whose reaction was utterly different from that of Kohn's large, supportive family. Barry wanted both David and Alice to attend family events. Lebe recalls, "It was as though Barry wanted two spouses. I don't think Alice liked it." Ultimately, neither did David. But Kohn's open demeanor and fearlessness had a lasting impact.

Kohn was among the first of Lebe's friends to die of AIDS, in June 1987. In the weeks beforehand, processing Kohn's sickness and impending death, Lebe felt a compulsion to work, much as he had with Blondeau some thirteen years earlier. This led to a new series of light drawings, made by moving his flashlight free-form in the air rather than outlining subjects. Barry died while he was making

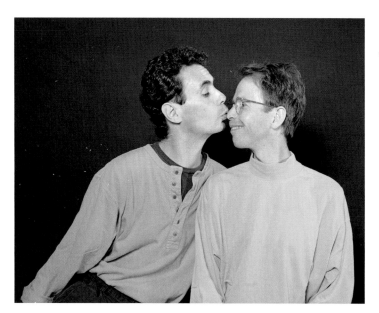

the photographs, and he did not think much of them at the time. In 1994 he explained to Kagan: "I had printed a few pictures but thought they were frivolous and silly, and that I really had a responsibility to be making work that dealt with AIDS as a topic. The work should be about depression, about pain, about anger — about serious things, not those playful patterns of light." Only later did Lebe change his mind, recognizing that these decorative images — which he titled *Scribbles* — are precisely about AIDS. At that point he printed and delicately hand colored many of them. "The pictures were really a defiance of the fear and the pain, a kind of celebration of the spirits of so many who had died. They are an affirming memorial coming from my experience of knowing so many."[28]

In 1989 Lebe met and fell in love with Jack Potter, a ceramic artist and horticulturist soon to become curator at the Scott Arboretum at Swarthmore College, outside of Philadelphia (fig. 20). Both men had AIDS. They shared a deep skepticism of the medical establishment and a strong will to live. Introduced by their mutual friend Jonathan Lax, a successful entrepreneur and important AIDS activist in Philadelphia, they soon joined an AIDS support group that Lax started. The group numbered around a dozen members using different approaches to manage the disease. In the early days of HIV and AIDS treatment, reliable knowledge was hard to find. Doctors and researchers were befuddled and confused, like most patients, yet were disinclined to pay attention to patients' knowledge. Lax — along with fellow activist Kiyoshi Kuromiya — was a critical resource for the Philadelphia community, aggregating data about treatment approaches throughout the country that he put into a standard of care for AIDS patients.[29] Potter remembers the various resources he and David relied on: "*Project Inform*, which I was reading even before I met David, and John James's *AIDS Treatment News*, both of which were West Coast publications. And Kiyoshi's fine newsletter published out of his Critical Path Project in Philadelphia."[30]

Lebe and Potter avoided drug monotherapies and relied little on doctors during their Philadelphia years, but they actively pursued a healthy diet. "There was an ad in the paper for a macrobiotic food group for people with AIDS," says Lebe. "All these people showed up, and they brought Christina Pirello in to lecture. She came dancing in with lots of food and was the life of the party and so much fun."[31] Pirello, who later hosted the PBS show *Christina Cooks!*, invited David and Jack to join her AIDS cooking class, which evolved into potluck dinner parties. Although they would briefly return to eating conventional food after they began combination drug therapies, today Potter is an accomplished whole foods, plant-based cook.

In 1992, Lebe and Potter's new preoccupation with their diet prompted Lebe to make a series of still-life photographs using the squashes, beans, and other

Fig. 20. David Lebe. *David & Jack*, August 7, 1992. Gelatin silver print, 7 × 9 inches (17.8 × 22.8 cm). Courtesy of the artist

ingredients that had taken on outsized importance in their daily lives. Staged and lit almost like high-production advertising photographs, these pictures are by turns humorous and poignant. He employed extended exposures and light drawing for some, conferring the power and energy to these vegetable subjects that he elsewhere gave to bodies. Yet the most telling feature of these photographs is their elegant and at times precarious balance. In their teetering, ordered-bordering-on-disordered compositions, they invoke themes as old as still life itself—harmony, excess, and the brevity of life—which Lebe subtly reorients toward AIDS and its personal and societal upheavals.

In 1989 Lebe's friend Scott Tucker introduced him to the porn star Scott O'Hara, whom Tucker—an activist, writer, and member of ACT UP Philadelphia—had met while touring the United States during his year as reigning International Mister Leather. O'Hara was visiting town and wanted Lebe to photograph him. Neither he nor Tucker knew that he was Lebe's favorite porn star; Lebe loved the authenticity of his sex scenes. The two men struck up a friendship, and Lebe would go on to photograph O'Hara four times over the next six years. During that same period, O'Hara became a widely published author and magazine editor until his death in 1998.[32] In Lebe's photographs we see O'Hara's body change as his AIDS progresses. O'Hara held controversial views about the sexual rights of infected people, and he called his own HIV status "an undeniable blessing."[33] In 1994 he had "HIV +" tattooed on his upper arm (see page 5).

Lebe's photographs focus on O'Hara's bodily pleasure and enjoyment before the camera. They are another manifestation of the artist's desire to work collaboratively. These images differ from Robert Mapplethorpe's famous exploration of similar subjects—which he began in the 1970s—by their emphasis on O'Hara's personal sexuality. Whereas Mapplethorpe's photographs are often overtly staged or cropped to objectify body parts and isolated sexual actions, Lebe's are about his subject's full presence in the world. In this his approach is closer to those of Hujar (who sometimes photographed homoerotic subjects) and Nicholas Nixon (who does not). Both of those artists, like Lebe, concentrate on bodily touch and subjective presence throughout their work.

In 2013 Lebe wrote movingly about the politics of sexual liberation in the 1970s and the importance of pornography in the 1980s for people with HIV and AIDS. "Our political energy moved from the intimate sexual and personal realms to the public realms of medicine and government. With that shift pornography took on a new importance in the lives of many gay men, changing from a casual diversion or an educational medium to a sustaining refuge, a place to withdraw and take stock. At least this was how I remember it being for me, in those years."[34] In the same text he describes his *Scott* photographs with these words: "They are about, in part, the refusal to give up on life or life's pleasures. A triumph of spirit over AIDS." Beginning in the mid-1980s, Lebe made numerous photographs of men enjoying their bodies, whether engaged in sexual self-pleasure or simply posing nude for his camera. He did not consistently use light drawing for these images, yet he considers them of a piece with the light

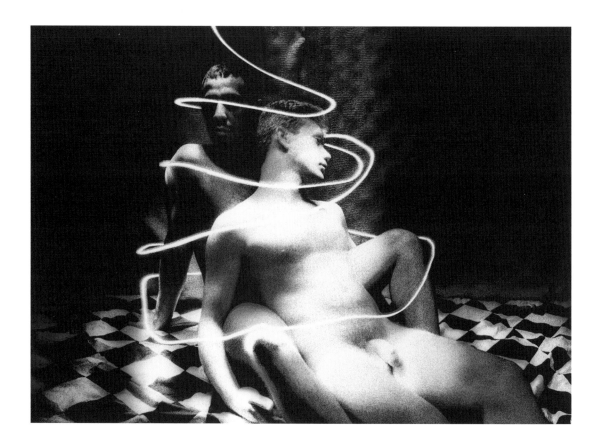

drawings from that period. Together, they form a moving record of the simple presence of gay men and their sexuality (fig. 21).

A photograph Lebe made of Bernard Welt in 1989 shows a more humorous side to this: Welt leans his head on a television showing a scene from a film by auteur director Toby Ross (see plate 72). Welt recalls: "It was very spontaneous. I was visiting David. He had two VCRs. TLA Video was in Philadelphia with a vast collection of porn. I taught about the overlap of experimental cinema and gay porn, so I would rent videos and copy them. David took the picture and said, 'Let's send this as a Christmas card!'"[35]

On February 15, 1990, Lebe and Tucker together attended a lecture by the artist David Wojnarowicz at the University of the Arts. Wojnarowicz had lost numerous friends to AIDS, including his mentor, Hujar, and was living with the disease. Much of his art at that point was directed toward an intensely angry and knowledgeable critique of the media, the medical establishment, politicians, and "family men" who demonized or simply marginalized the communities most at risk from AIDS. He used lectures not to talk about his work but to confront audiences with the civic crisis surrounding the disease. His Philadelphia lecture is remembered by several attendees as a distressing and emotional event. Tucker, who knew Wojnarowicz slightly from their participation in ACT UP, became quite upset in the course of asking a question. Lebe remembers sitting next to

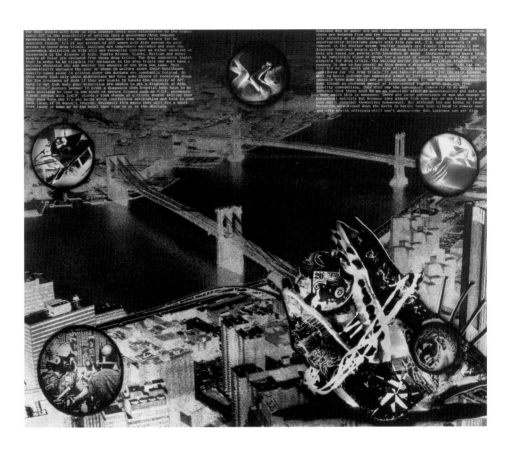

him and holding his hand, feeling alienated in the place where he had studied and worked for half his life. One of his photographs of O'Hara masturbating had recently been excluded from a faculty exhibition (see plate 54). Although he did not think the exclusion was entirely unreasonable, it pained him; he felt it was important to insist upon his presence as a queer artist and faculty member.

Despite the radically different tenor of their work, Wojnarowicz's art is germane to understanding Lebe's. Wojnarowicz made work about AIDS that is confrontational and angry, while Lebe's is contemplative and loving. Yet both operated with fearless candor, placing primacy on human touch and sexuality. Wojnarowicz's *Sex Series*, from 1988–89, comprises eight photographs made with montaged found images printed in reverse, like negatives, and sometimes overlaid with typescript text. *Untitled (New York Bridges with Text)* is an aerial view of the city with round inset images that float like T cells or viruses (fig. 22). These images are purposely hard to see, but include sex acts, a human baby in the womb, and men in combat gear. At the bottom of the scene, a monstrous fish-like creature gobbles one packed with money. Hovering above everything is a dense typescript report about bureaucratic barriers to health care for New Yorkers with AIDS — the homeless, people of color, prisoners, lesbians and most other women. This dystopia could almost be the inverse of one of Lebe's painted photograms of an imaginary landscape, but for this: despite its fantastical setup, it is loaded with terrible facts.

Fig. 22. David Wojnarowicz (American, 1954–1992). *Untitled (New York Bridges with Text)*, from *Sex Series (for Marion Scemama)*, 1988–89. Gelatin silver print, 14 13/16 × 17 ¾ inches (37.6 × 45.1 cm). Philadelphia Museum of Art. Gift of Marion Boulton Stroud, 2009-225-8

In 1992 Lebe and Potter began construction of a house with healthy, toxin-free materials in Columbia County, New York, where they moved in 1993 and live today. At the time they did not anticipate many years ahead of them. They continued to follow the healthy regimens they had established in Philadelphia and maintained their distance from conventional medicine. In 1996, Potter declined and they both expected him to die. Lebe reached out to the AIDS Council of Northeastern New York, which put him in contact with the AIDS clinic at Albany Medical Center. In December, Jack started HIV combination drug therapy, and Lebe followed in January. They continue with their therapies today and credit their survival to the drug combinations, their own independent actions in the years beforehand, and good luck.

Lebe recalls his and Jack's first years in their new house, before they started treatment, as an insular period of limited energy and activity. "We had a one-thing-a-day rule. If we went grocery shopping, we didn't go out to eat. If we had an acupuncture appointment, we didn't visit a friend." Yet he continued to photograph, focusing on the intimate life they had created together. In the summer of 1994 he made the series *Morning Ritual*, following Jack in his daily ablutions and preparations. Lebe does not know how he found the stamina to make these photographs. "Maybe what got me started was the comfort I felt watching Jack carefully going through his morning routine, or maybe it was just the sheer pleasure of capturing the light that filled the upstairs of our house most mornings that summer. What I can say for sure is that making these pictures was a pleasure and I gave little thought to how or when I'd print them."[36] When he did ultimately print them, with the help of an assistant, John Snyder, from November 1995 until April 1996, Jack's decline was accelerating. That summer and continuing into 1997, David made the series *Jack's Garden*, close views of the remarkable garden Potter cultivated around their house and still maintains today. Lebe eventually printed both *Morning Ritual* and *Jack's Garden* at an intimate scale and arranged them into separate, matching portfolios. Together they constitute a visual love poem about Jack and their first years together at that house, a period when Lebe recalls they felt "suspended from the world." *Morning Ritual* records Jack's presence and graceful movements; *Jack's Garden* shows his glorious creation, translated by David into subtle and luminous silver images.

Lebe dove into digital photography in 2004. At once daunted and exhilarated by this almost entirely new way of making photographs, he spent years learning it. The possibilities opened up by inkjet printing brought him—at last—to a mode of color photography he embraced. He returned to Jack's garden and the landscape around their house to create the series *On May Hill* (fig. 23). The colors in these photographs are truer to nature than his earlier hand-painted pictures, yet they still bear the stamp of his unique color sensibility.

Fig. 23. David Lebe. *On May Hill: Campion Sundown*, c. 2005 (image file), 2015 (print). Pigment print, 20 1/16 × 13 5/16 inches (50.9 × 33.8 cm). Philadelphia Museum of Art. Gift of the artist, 2016-30-110

Fig. 24. Barbara Blondeau. Untitled, from the series *Black Borders*, 1974. Gelatin silver print, 9⅝ × 6½ inches (24.5 × 16.5 cm). Philadelphia Museum of Art. Purchased with the Julius Bloch Fund Created by Benjamin D. Bernstein, 2018-94-11

He also returned to earlier projects, as is his wont. Inkjet printing finally made possible the pinhole prints he had always imagined making.

In 2012 Lebe began a new series of photographs he calls *ShadowLife*. These pictures of shadows at home are deceptively complex, despite their simple premise. He makes them around sunrise, a time for long light. Vases perch and tilt at the edges of things. Light filters through colored glass, casting otherworldly specters. Lebe includes himself in numerous views, unflinching before the toll of years. He relates these productions to his photograms, which, he points out, are shadow pictures of a sort. But they go back even further, to his own student projects and the examples of his mentors, Blondeau and Metzker, both of whom loved shadows. Close to the end of her life, Blondeau produced a small series she titled *Black Borders*, showing various subjects surrounded by a wide black field. In one of them we see the long shadows of two people and a dog on an afternoon walk (fig. 24). The shadow on the right presumably belongs to Blondeau, whose arms appear raised in the act of taking a photograph. But all we really know about these figures is that they were together and for a few moments took pleasure in the sun.

David Lebe's art is about his life—his friendships, loves, objects, pleasures, and losses. It is also about human connection, the joys and mysteries of the natural world, and the presence of death in all of life. Just as his home is a serene

extension of his artistic ethos, so are his friendships. He treats each one with loving care. So it is fitting to close with words from one of his friends. Seth Eisen met Lebe as a very young gay man in the 1980s. "My most salient memory about David in that era is that there was no shame about sex," says Eisen. "He already understood, which was a leap for me, that gay sex was a positive thing that we should be proud of. It's something magical and wonderful and should be cherished. It's sparkly and nuanced and complex, just like it appears in his pictures. And AIDS didn't change that at all. That made a big impression on me."[37]

Fig. 25. Priscilla "Ter" DePuy (American, 1942–2011). *David, Higbee Beach, Cape May, New Jersey*, September 5, 1983. Gelatin silver print, 4⅞ × 3½ inches (12.4 × 8.9 cm). Courtesy of David Lebe

Notes

1. Amin Ghaziani, *The Dividends of Dissent: How Conflict and Culture Work in Lesbian and Gay Marches on Washington* (Chicago: University of Chicago Press, 2008), 94–95, 100, 123. On *Bowers v. Hardwick*, see Joyce Murdoch and Deb Price, *Courting Justice: Gay Men and Lesbians v. the Supreme Court* (New York: Basic Books, 2001), especially 271–354. That decision was ultimately overturned by the 2003 ruling in *Lawrence v. Texas*.

2. Publications that focus on Lebe's work in whole or in part include *Truth Fantasy: David Lebe Photographs*, exh. cat. (Baltimore: Albin O. Kuhn Library & Gallery, University of Maryland Baltimore County, 1986); "David Lebe: Panoramic Pinhole Photographs, 1969–1975," special issue, *Pinhole Journal* 10, no. 2 (August 1994); Lauren Smith, *The Visionary Pinhole* (Salt Lake City: Gibbs M. Smith, 1985); Paula Marincola, ed., *The Hand Colored Photograph*, exh. cat. (Philadelphia: Philadelphia College of Art, 1979).

3. See the "History" and "Philosophy" sections on the City and Country School's website, www.cityandcountry.org. For more on the school, see Caroline Pratt, *I Learn from Children: An Adventure in Progressive Education* (1948; repr., New York: Grove, 2014).

4. David Lebe, conversation with the author, Ghent, New York, June 6, 2018.

5. On the photography program at ID, see David Travis and Elizabeth Siegel, eds., *Taken by Design: Photographs from the Institute of Design, 1937–1971*, exh. cat. (Chicago: Art Institute of Chicago in association with University of Chicago Press, 2002). Metzker arrived at PCA in 1962; Porett came in 1966, the same year Lebe arrived as a freshman; Blondeau came to Philadelphia to teach at Moore College of Art and Design in 1968 and joined the faculty at PCA in 1970.

6. Lebe, conversation; Susan Welchman, conversation with the author, June 15, 2018; Alan and Linda Eastman, conversation with the author, July 20, 2018.

7. One of Lebe's early photographic efforts, now in the collection of the Philadelphia Museum of Art (accession no. 2016-30-4), further demonstrates his interest in civil protests. It is an uncompleted album of the massive New York City antiwar marches on April 15, 1967, known as the Spring Mobilization to End the War in Vietnam.

8. Lebe, conversation.

9. Richard Kagan, "An Interview with David Lebe." *Photo Review* 18, no. 2 (Spring 1995): 3. An earlier version of this interview appeared in *Pinhole Journal* 10, no. 2 (August 1994): 7–28.

10. Welchman, conversation.

11. Welchman, conversation.

12. Richard Kagan, conversation with the author, July 18, 2018. Kagan attended Temple University 1962–65.

13. Lebe, conversation.

14. David Lebe, correspondence with the author, July 4, 2018.

15. Jane Futcher, conversation with the author, July 19, 2018. Futcher went on to become a noted author of short stories and novels, including *Crush* (New York: Avon, 1981).

16. David Lebe, Joan S. Redmond, and Ron Walker, eds., *Barbara Blondeau, 1938–1974* (Rochester, NY: Visual Studies Workshop, 1976).

17. Kagan, "Interview with David Lebe," 4.

18. Paul Cava, conversation with the author, June 29, 2018

19. Seth Eisen, conversation with the author, July 21, 2018.

20. Lebe, conversation; Barbara Crane, conversation with the author, June 28, 2018.

21. Lebe, conversation.

22. Kagan, "Interview with David Lebe," 6.

23. Robert Hirsch, *Transformational Imagemaking: Handmade Photography since 1960* (New York: Focal Press, 2014).

24. Cava, conversation.

25. Marcuse Pfeifer, conversation with the author, June 25, 2018.

26. *The Male Nude: A Survey in Photography*, exh. cat. (New York: Marcuse Pfeifer Gallery, 1978). This brief publication includes an introduction by Shelley Rice.

27. Barry Kohn and Alice Matusow, *Barry and Alice: Portrait of a Bisexual Marriage* (Englewood Cliffs, NJ: Prentice-Hall, 1980).

28. Kagan, "Interview with David Lebe," 5–6.

29. Jonathan Lax obituary, *Philadelphia Inquirer*, January 12, 1996.

30. Jack Potter, email message to author, June 11, 2018. Project Inform, an early presence in the community-based HIV research movement, was founded by Martin Delaney in San Francisco in 1985. *AIDS Treatment News*, still in publication, was founded by John S. James in San Francisco in 1986. Kiyoshi Kuromiya, a civil rights and antiwar activist, founded the Critical Path Project in Philadelphia in 1989 based on the ideas of his mentor, R. Buckminster Fuller, regarding uses of technology to disseminate information.

31. Lebe, conversation.

32. In 1993 O'Hara founded the sex journal *STEAM*, of which he was also editor. His books include *Autopornography: A Memoir of Life in the Lust Lane* (New York: Harrington Park, 1997), which features a Lebe photograph on its cover (*Scott: Shadow Play*, plate 46 in this volume), and *Rarely Pure and Never Simple: Selected Essays of Scott O'Hara* (New York: Haworth, 1999).

33. O'Hara, *Autopornography*, 129.

34. David Lebe, "About the Scott Photographs" (2013), www.davidlebe.com.

35. Bernard Welt, conversation with the author, June 25, 2018.

36. David Lebe, "About Morning Ritual: A Different Time" (October 15, 2010), www.davidlebe.com.

37. Seth Eisen, conversation with the author, July 21, 2018.

Plates
1970–1987

The plates in this section come from a period of broad experimentation by Lebe in basic ways of making photographs. Frustrated by what he describes as the abstraction of camera technology, he turned to simple, direct methods that also permitted significant hand work. He started with pinhole photographs, using lensless cameras with multiple apertures to photograph friends, himself, and other subjects. He eventually moved on to photograms, which require no camera at all, and light drawings, which rely on a traditional camera with extended exposure times to record the movements of a handheld light source. These approaches permitted him to slow down the picture-making process and involve himself in the photographs. The pinholes and light drawings also invited collaboration between artist and model, which he loved.

In 1973 Lebe began experimenting with color film for pinhole photographs. Dissatisfied with the prints he could make, he soon turned to the laborious technique of hand coloring, which allowed him to import his singular color sense into his pictures. He produced a small series of straightforward portraits with elaborate hand coloring, which he dubbed *Unphotographs* because of their unorthodox combination of photography and painting. He also colored many examples of his other pictures. His most fanciful painting appears in his photograms, otherworldly arrangements of plant elements and other motifs that he often called "gardens" or "landscapes."

The culmination of Lebe's light drawings is a series of freehand sketches he made in 1987 when a close friend was dying of AIDS. He called them *Scribbles* and considered them frivolous at the time. Later he came to view them as significant pictures about his experience of AIDS and its losses. Over the ensuing decade he would produce several other series about the disease.

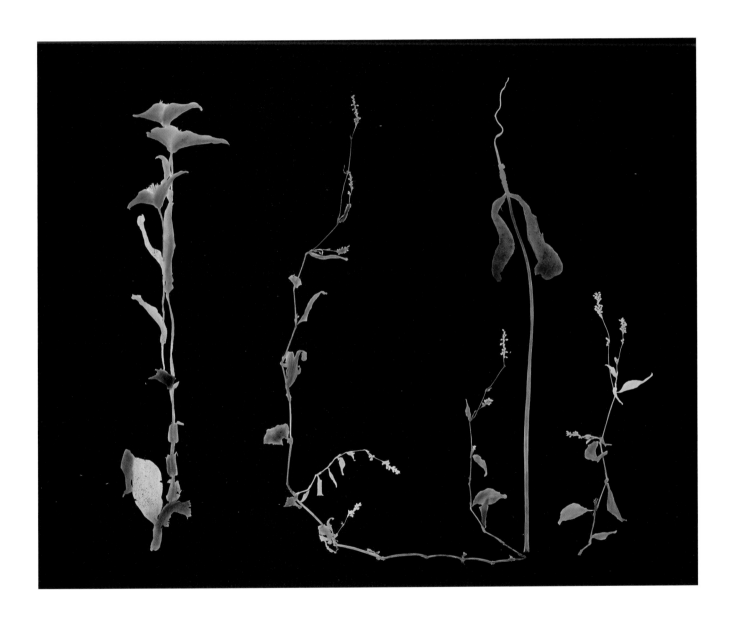

1. *Garden Series #26*, 1979 (negative), 1985 (print)

2. *Susan, Blue Dress*, 1973

3. *Wink: Self, Memorial Hall, Philadelphia,* 1974

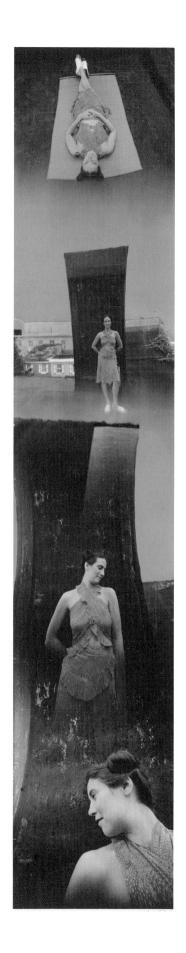

4. *Susan, Green Dress*, 1973

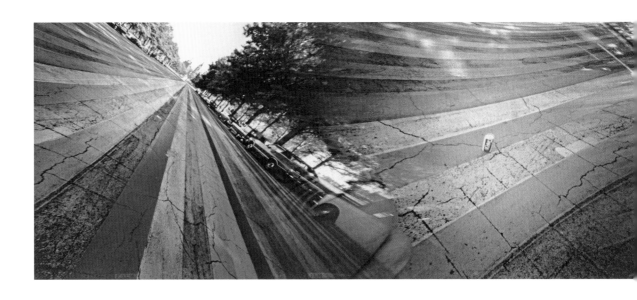

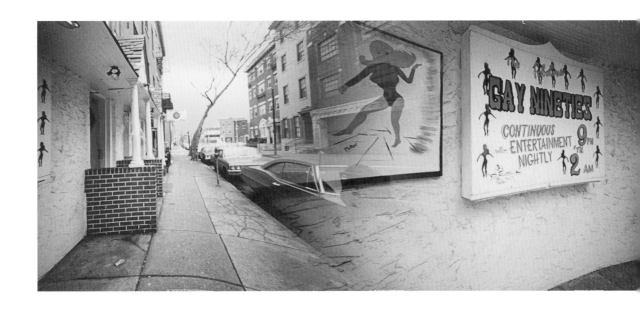

8. *High Adventure: Wandering the City with Terry (on "Franklin's Footpath" by Gene Davis)*, 1973 (color transparency), 2015 (print)
9. *Gay Girl / Straight Bar: 11th Street, Philadelphia*, 1973 (color transparency), 2015 (print)

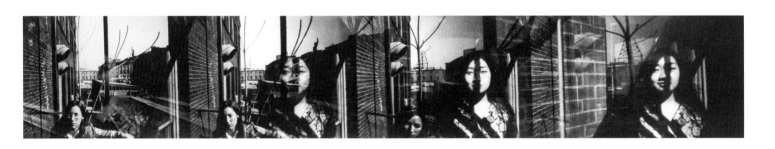

5. *Seven Photographers Seventy-Five*, 1975 (negative), 2015 (print)
6. *Head and Hand, Jessie*, 1970 (negative), 2015 (print)
7. *May Sam & Lynn*, 1970 (negative), 2015 (print)

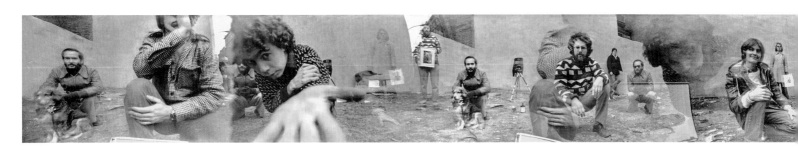

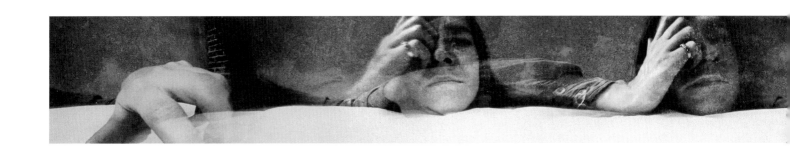

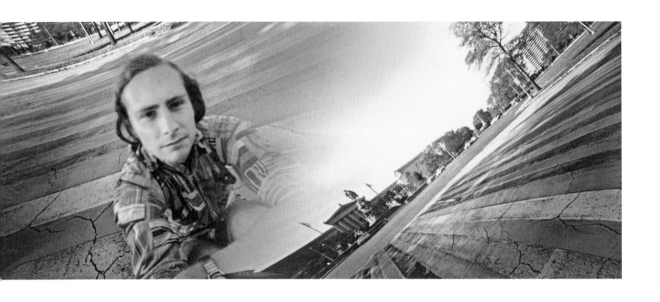

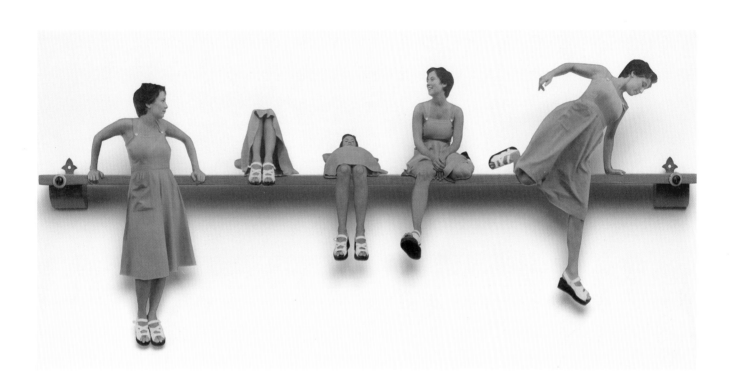

10. *Susan on Shelf*, 1974 (negatives), 1975 (prints and object)

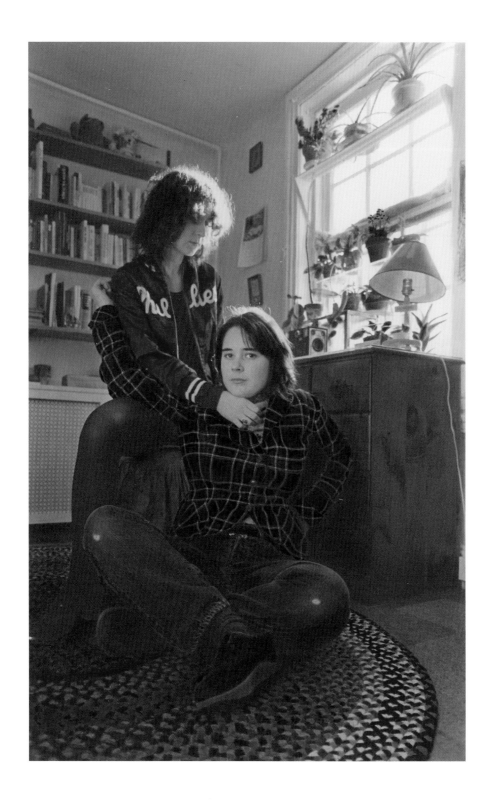

11. *Unphotograph Three – Joe & Chris*, March 22, 1974 (negative), c. 1974–75 (print)

12. *Unphotograph One – Edith Neff*, February 10, 1974 (negative), c. 1974–75 (print)

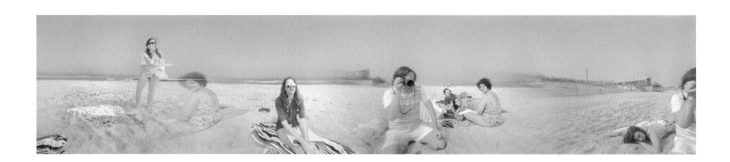

13. *Hazy Day Beach: Beach Haven*, 1975 (color transparency), 2016 (print)

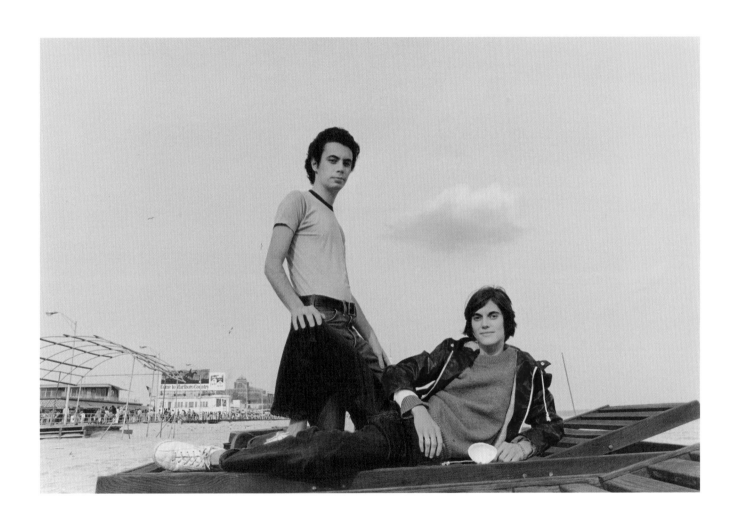

14. *Unphotograph Five – Atlantic City*, May 26, 1974 (negative), c. 1974–75 (print)

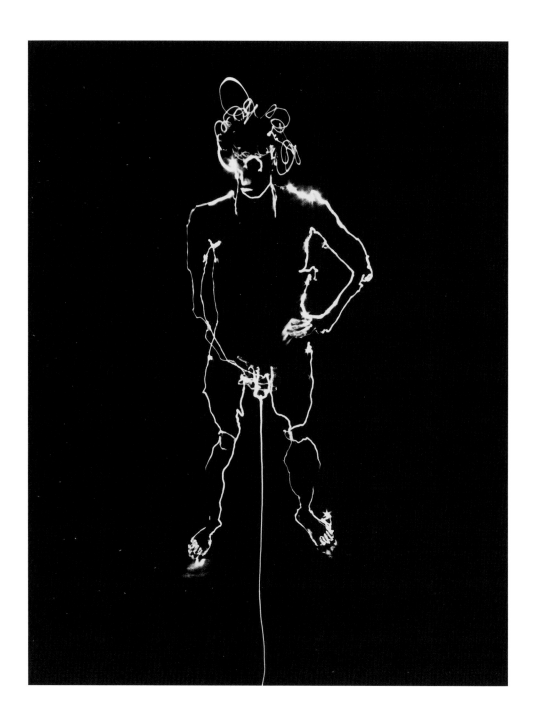

15. *Self-Portrait #6, Pissing*, 1977 (negative), c. 1996 (print)

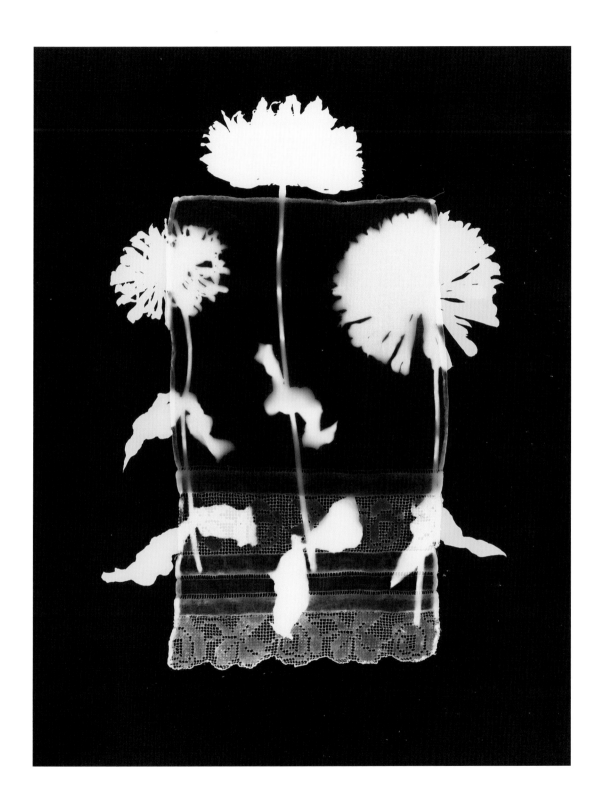

16. *Specimen #14*, 1978

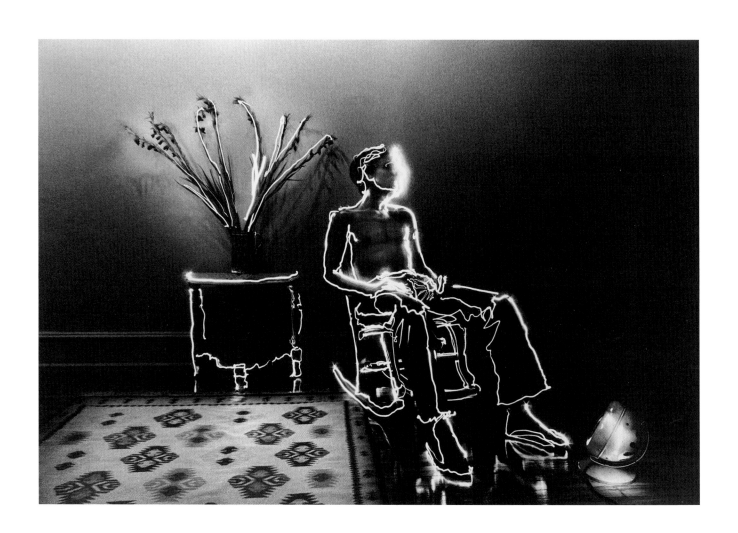

17. *Barry in Rocker*, 1979

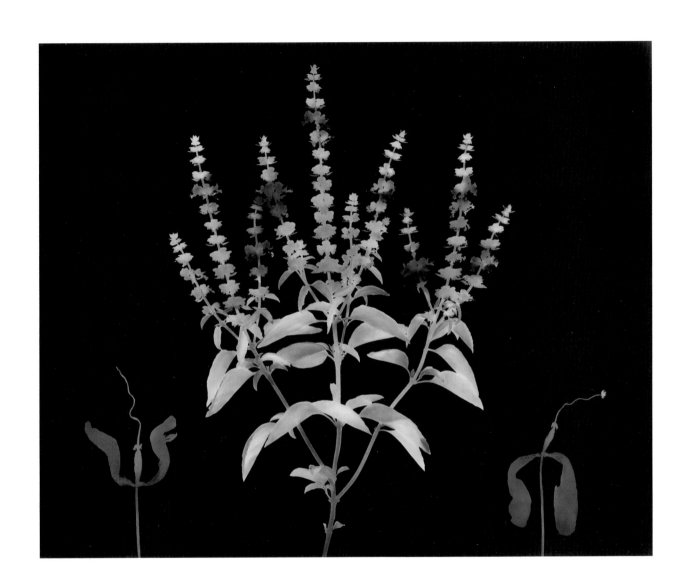

18. *Garden Series #1*, 1979

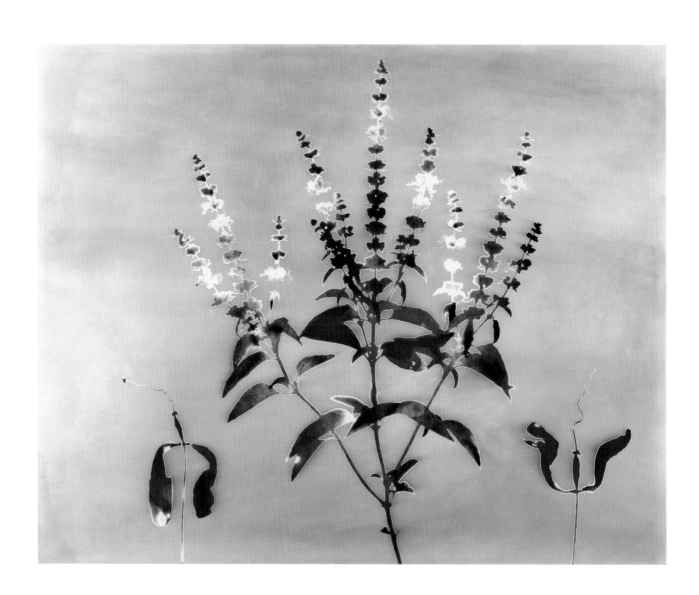

19. *Garden Series #3*, 1979

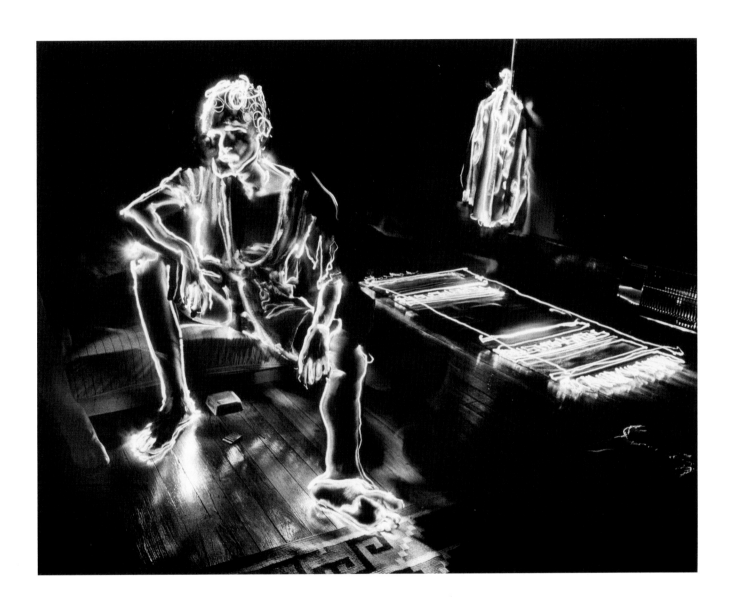

20. *Angelo in Robe*, 1979 (negative), 1995 (print)

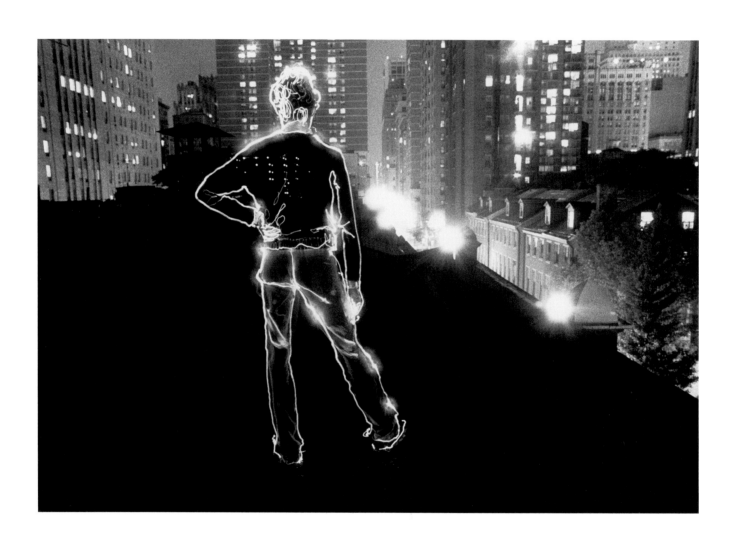

21. *Angelo on the Roof*, 1979 (negative), 1995 (print)

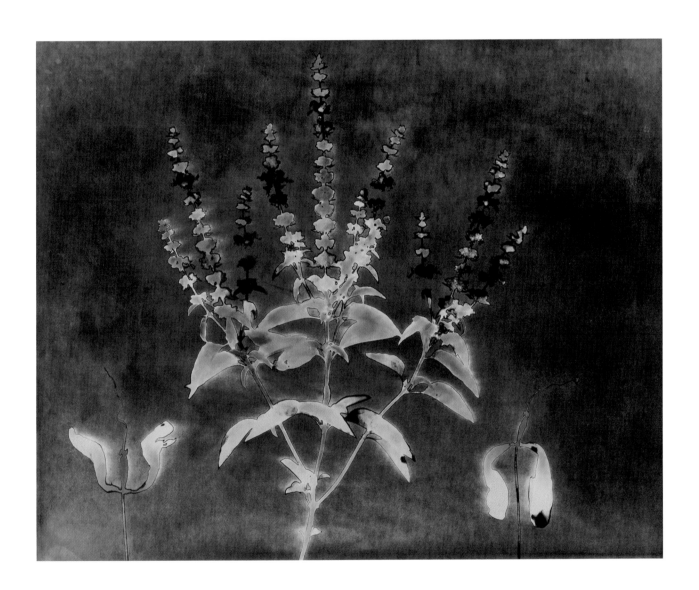

22. *Garden Series #4*, 1979

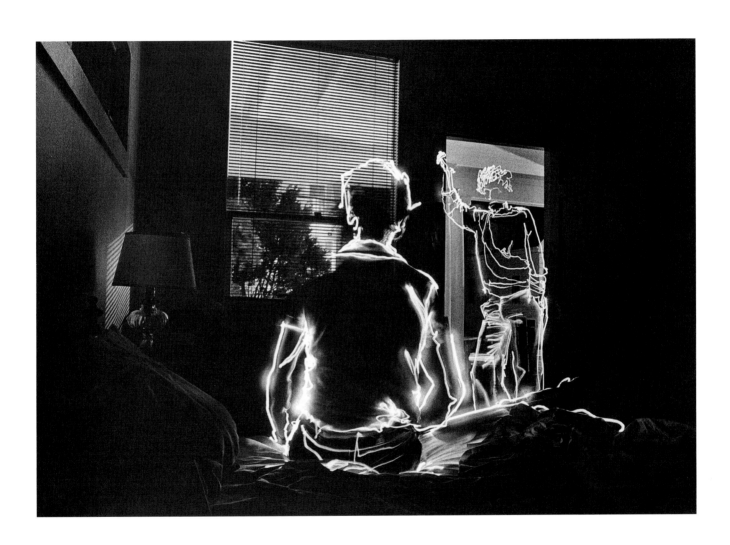

23. *Provincetown*, July 1980 (negative), 1983 (print)

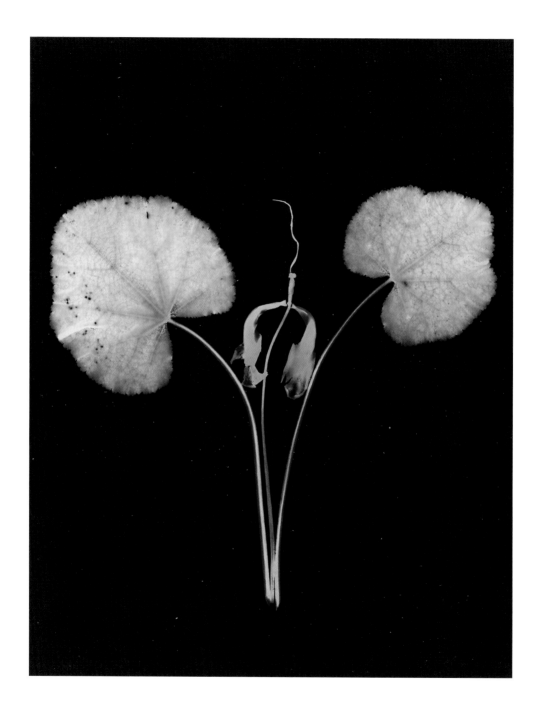

24. *Specimen #18*, 1980

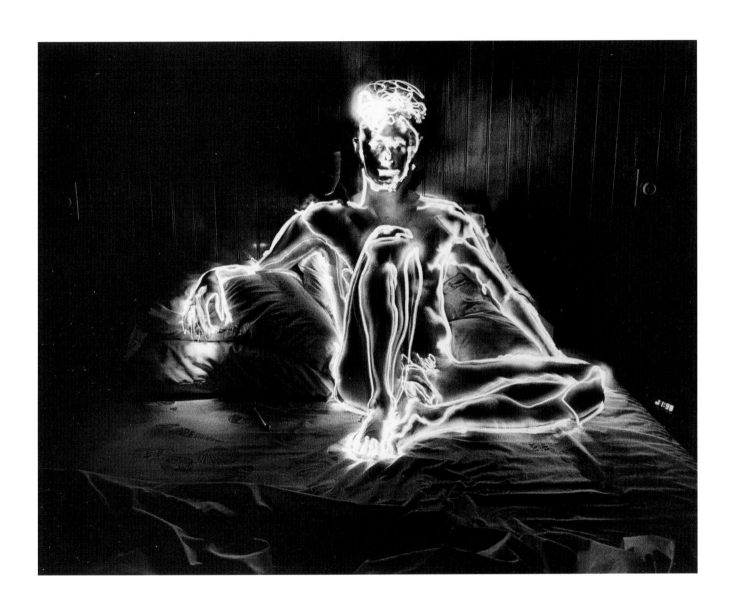

25. *Self 11:98*, 1981 (negative), 1985 (print)

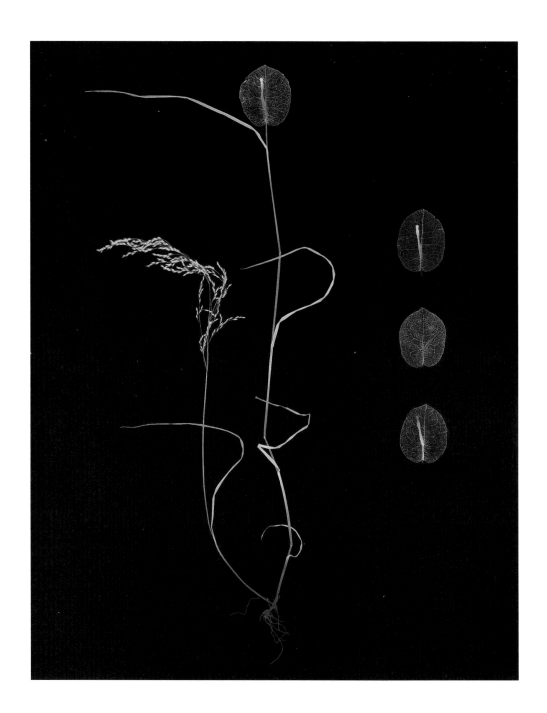

26. *Specimen #1*, 1981

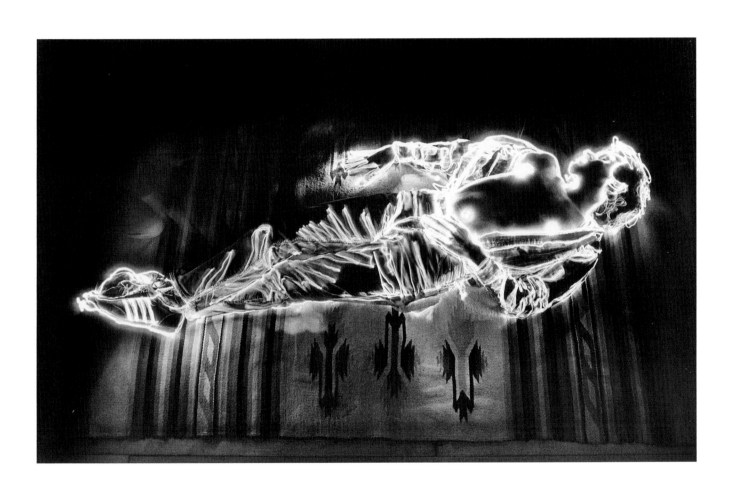

27. *Boy Dream*, 1981 (negative), 1989 (print)

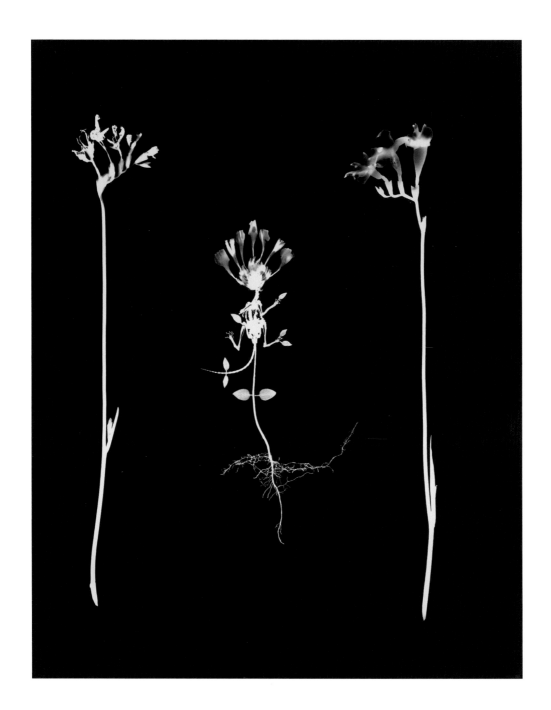

28. *Specimen* (unnumbered), 1981

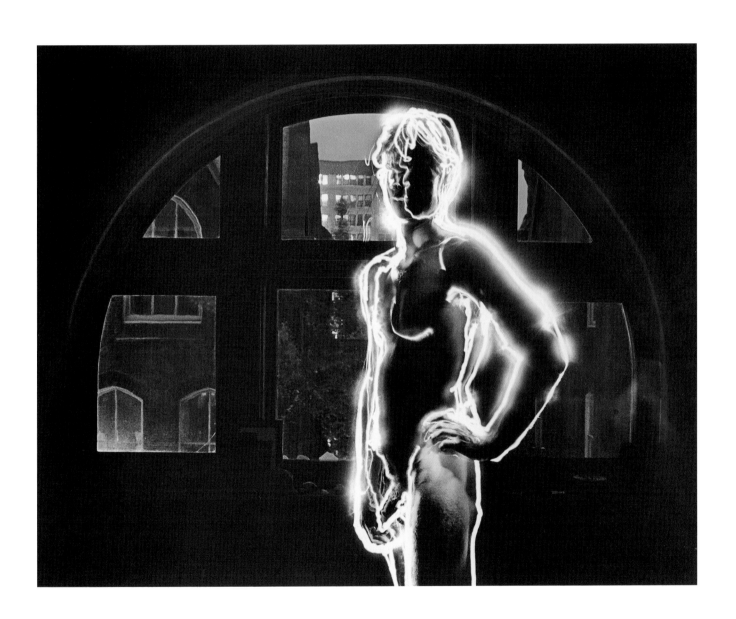

29. *Wayne at the Window*, 1980 (negative), 1981 (print)

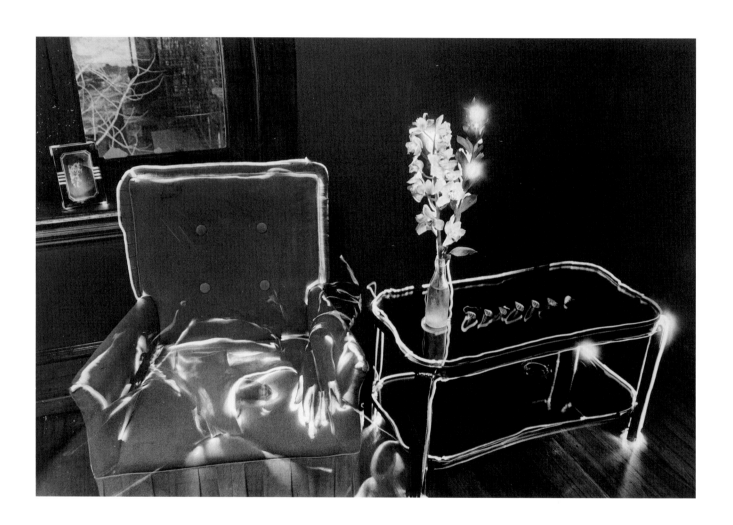

30. *Self-Portrait with Orchid*, 1982

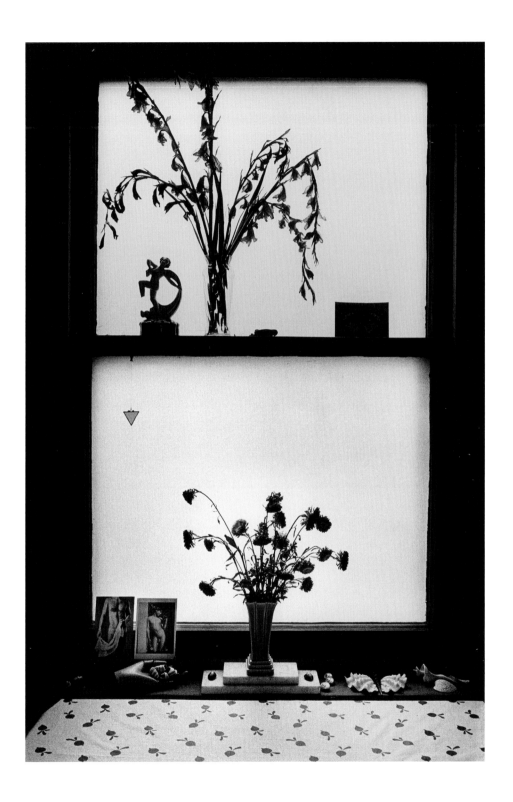

31. *The Window*, 1982 (negative), 1995 (print)

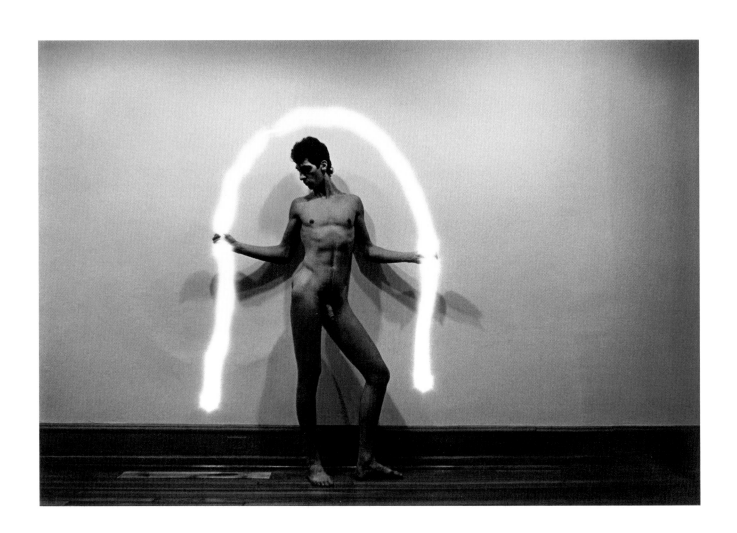

32. *Renato's Arc*, 1983 (negative), 1984 (print)

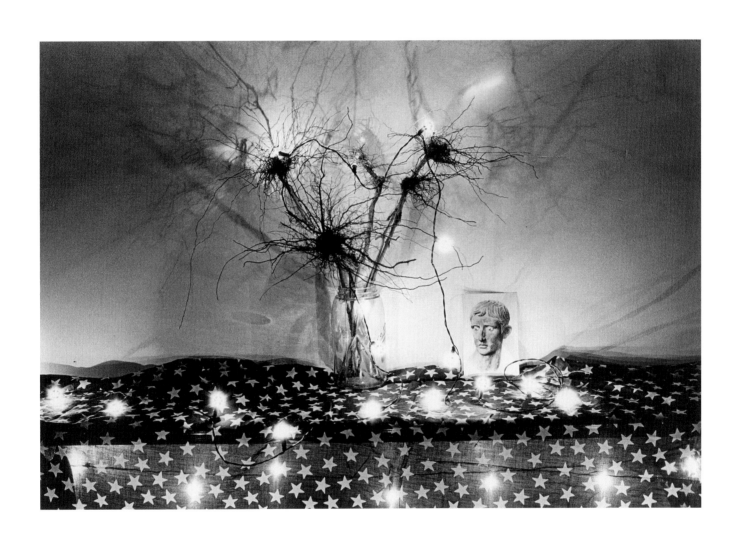

33. *Roots*, 1982 (negative), 1985 (print)

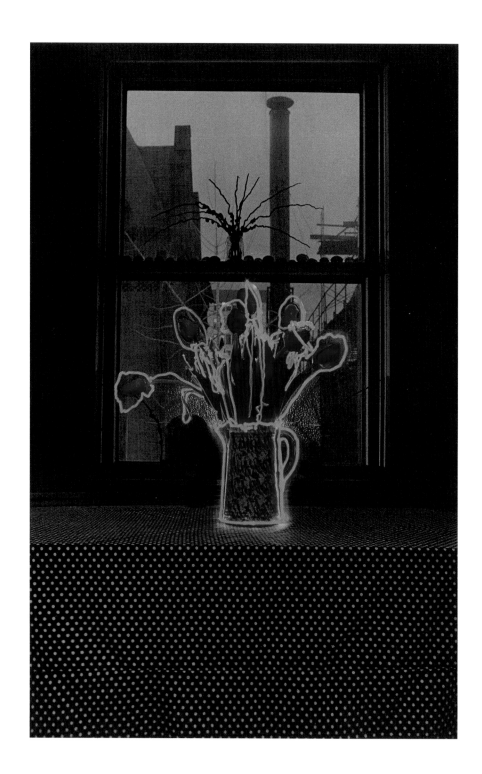

34. *Tulips Outlined in Red Light (Sketch)*, 1982 (negative), 1983 (print)

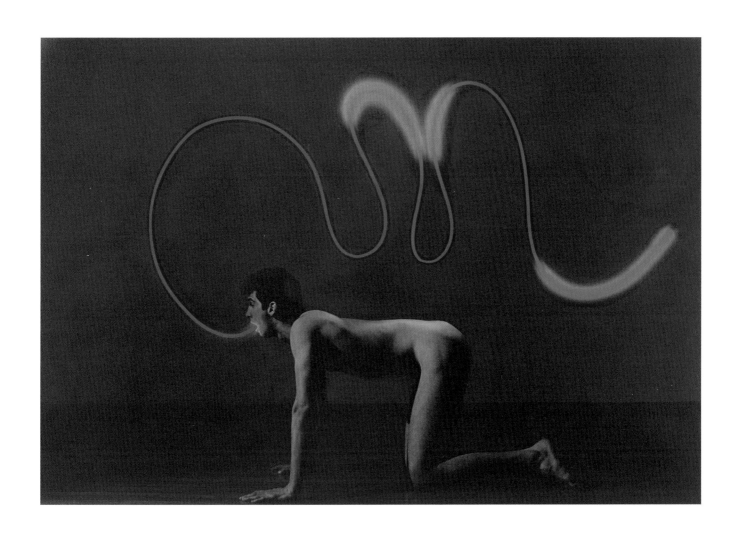

35. *Dragon Boy, Renato*, 1983

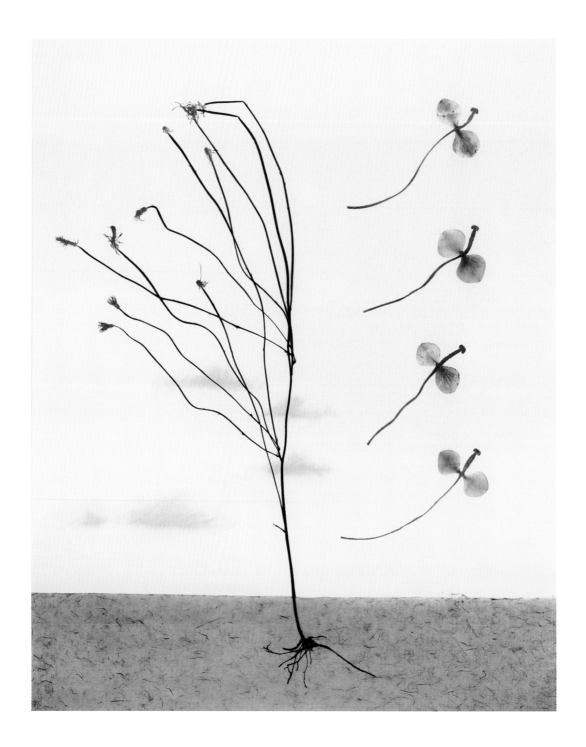

36. *Landscape #21*, 1985

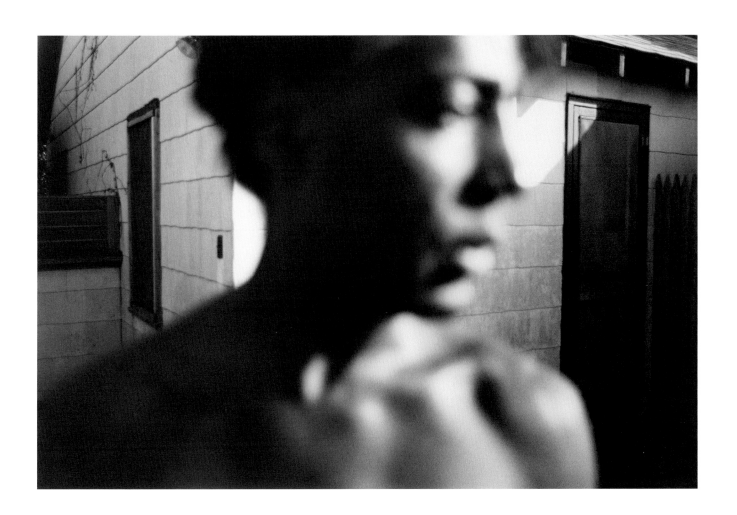

37. *Vaughn Stubbs, Fire Island*, 1985 (negative), 1987 (print)

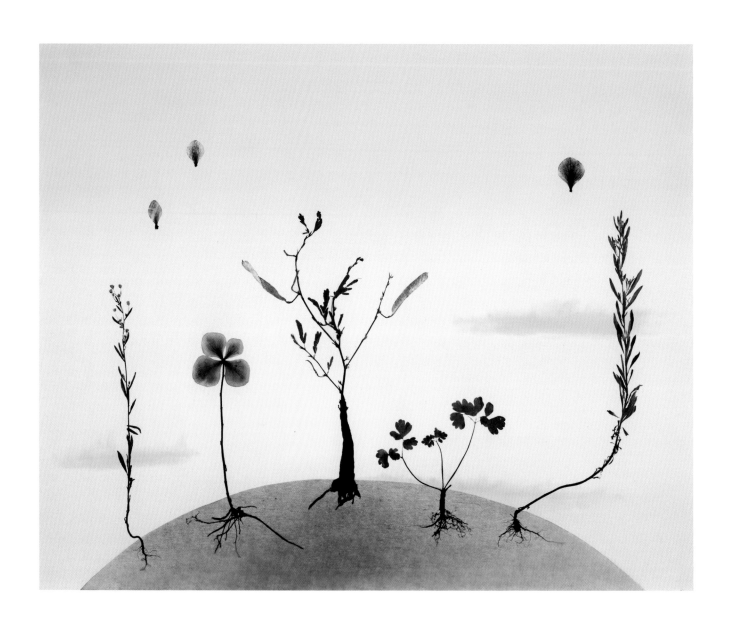

38. *Landscape #10*, 1985

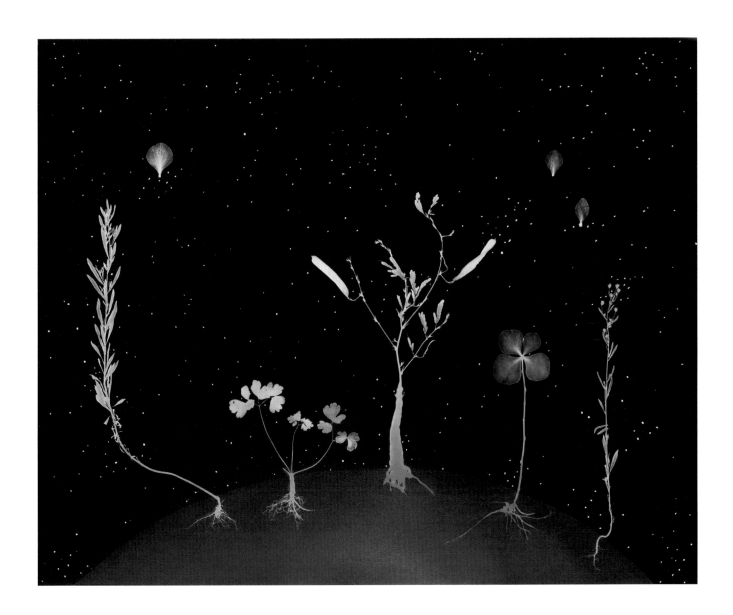

39. *Landscape #33*, 1985 (negative), 1986 (print)

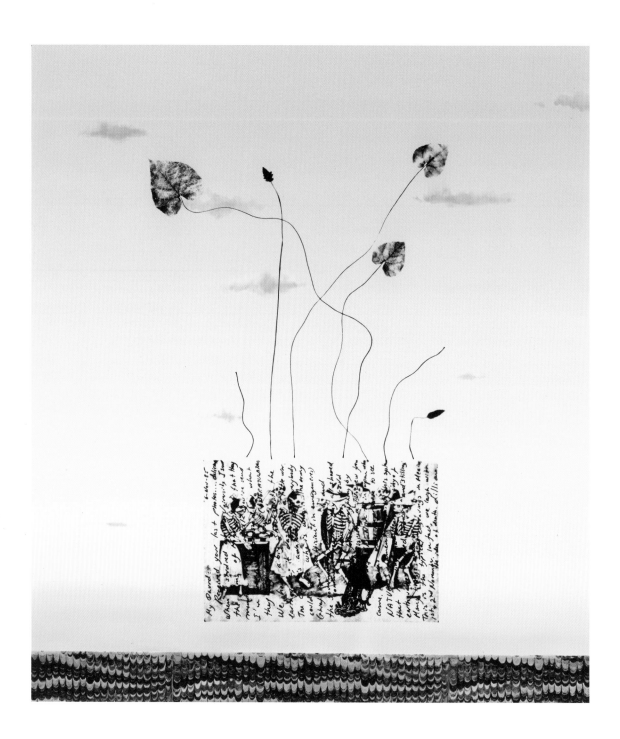

40. *In Fact We Laugh with the Idea of Death #3*, 1986 (negative), 1987 (print)

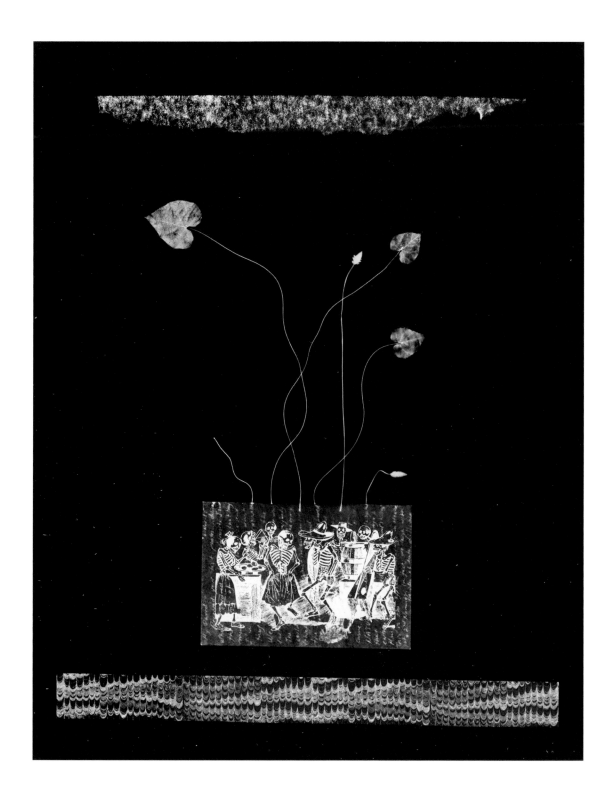

41. *In Fact We Laugh with the Idea of Death*, 1986

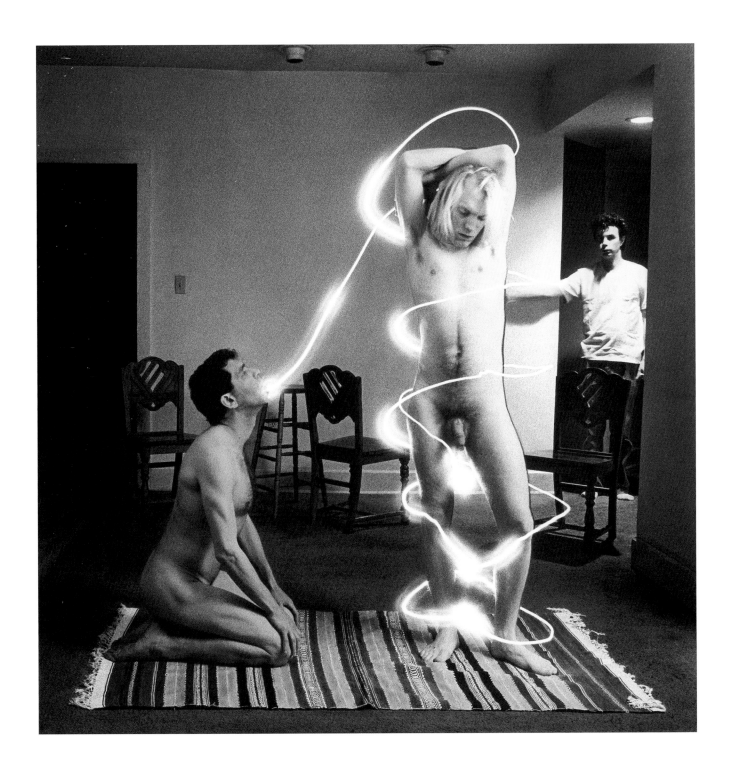

42. *Bernard, Grady & Me*, 1986 (negative), 1988 (print)

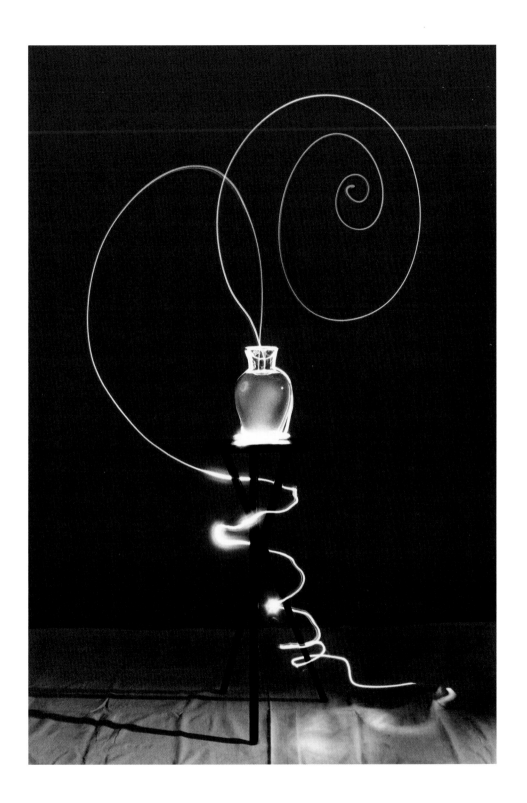

43. *Scribble #2*, 1987 (negative), 1988 (print)

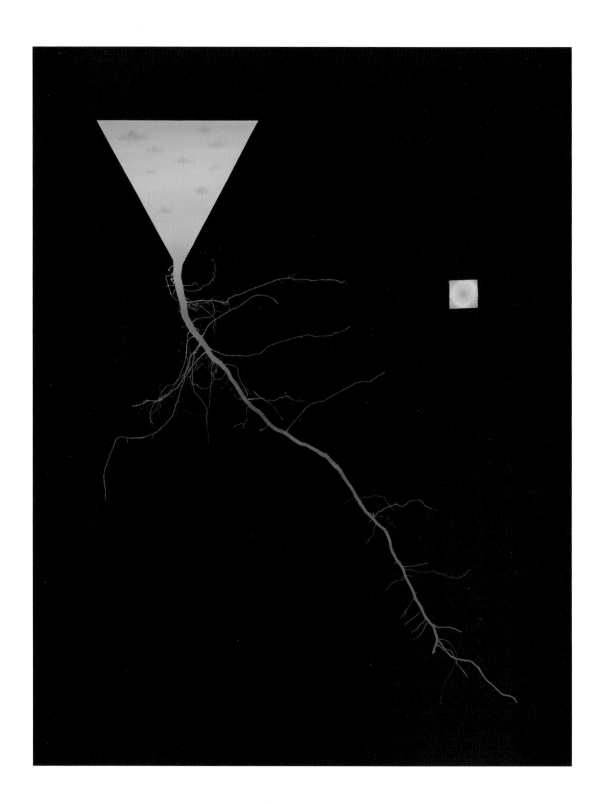

44. *Floating Landscape #3*, 1986 (negative), 1987 (print)

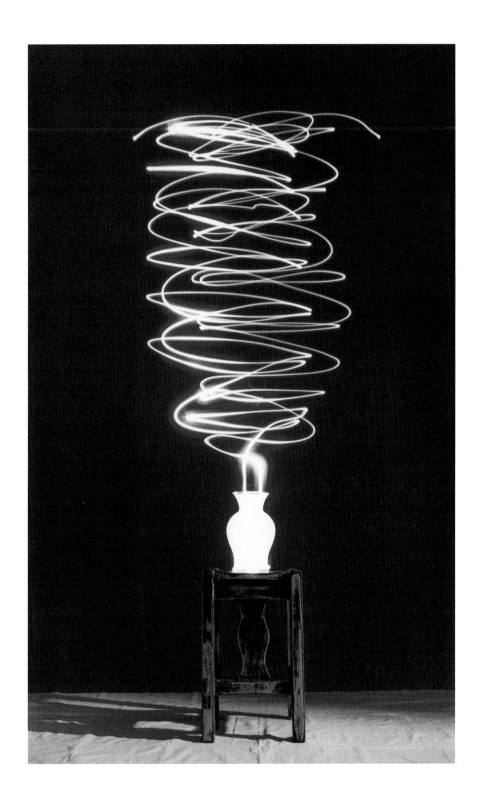

45. *Scribble #17*, 1987 (negative), 1988 (print)

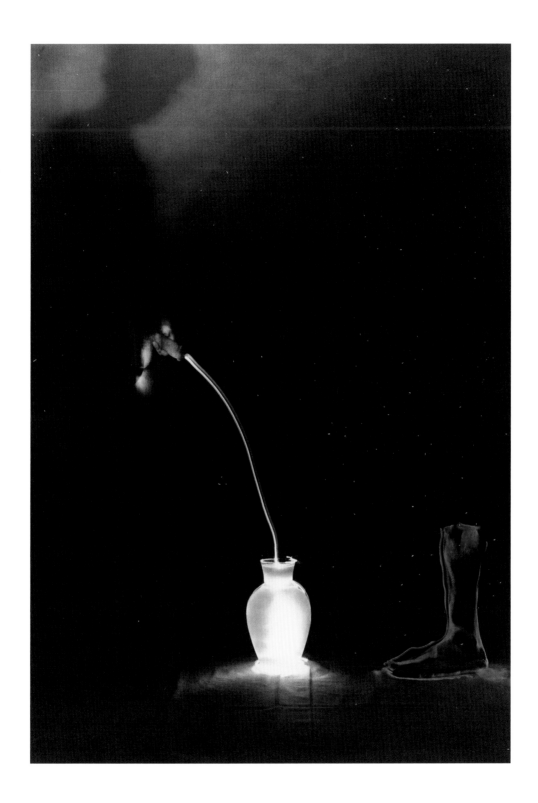

46. *Shadow Play*, 1987 (negative), 1991 (print)

Plates
1987–2017

In the decade from 1987 to 1997 Lebe produced diverse photographs, beginning with his abstract *Scribbles*. His ongoing attachment to formal experimentation was slowly matched by his desire to document gay experience, and by the late 1980s he occasionally photographed friends and acquaintances expressing their sexuality or enjoying their own bodies. This culminated in his extended series about the porn star and writer Scott O'Hara, whom he photographed four times between 1989 and 1996. These erotic pictures counter the absences in the *Scribbles* with the concrete presence of gay bodies.

In 1992, after adopting a macrobiotic diet in his effort to remain healthy, Lebe made the still-life series *Food for Thought*. He sometimes employed the light drawing and extended exposures characteristic of his earlier work, but here they bespeak the tenuous nature of personal well-being and of the larger social fabric. Following his 1993 move to Columbia County, New York, with his partner, Jack Potter, he created personal work of a different nature. *Morning Ritual* (1994–96) and *Jack's Garden* (1996–97) are portfolios of small, exquisite gelatin silver prints about their home and daily routines, which together stand as a quiet affirmation of life in the face of AIDS.

In 2004 Lebe began experimenting with digital photography, which allowed him to explore color printing with much greater control. He embraced the possibilities opened up by Photoshop, using his digital files as starting points from which to craft idiosyncratic prints. He returned to the landscape around his home for the series *On May Hill* (2004–9). With the series *ShadowLife*, begun in 2012, he has extended themes first explored in *Food for Thought*, recording the ephemerality of the material world.

47. *Scott*, 1991 (negative), 2015 (print)

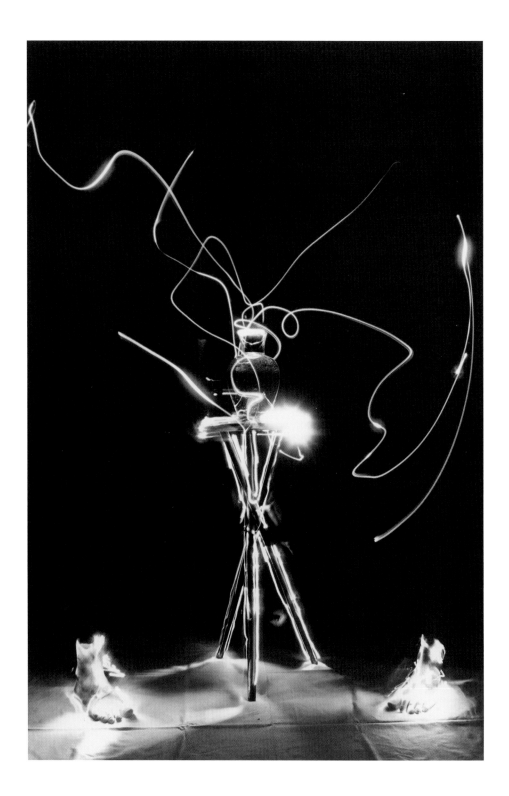

48. *Scribble #6, Feet*, 1987

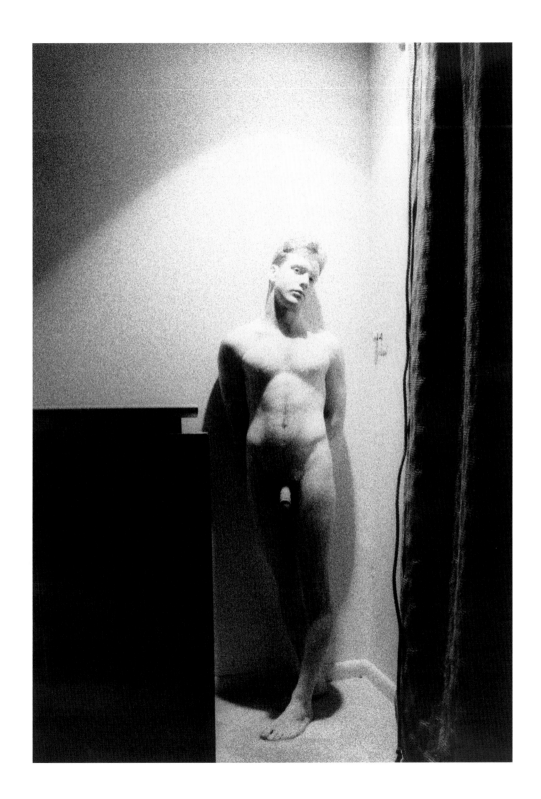

49. *Seth*, 1987 (negative), c. 1991 (print)

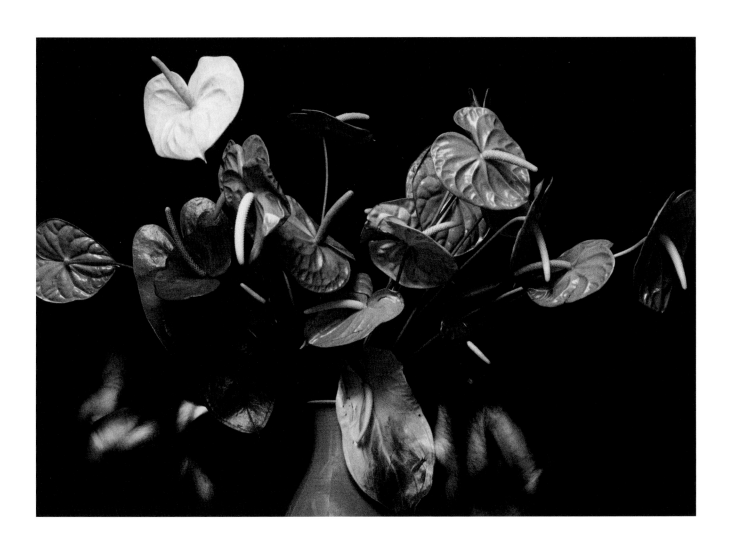

50. *Anthurium Display*, 1988 (negative), 1995 (print)

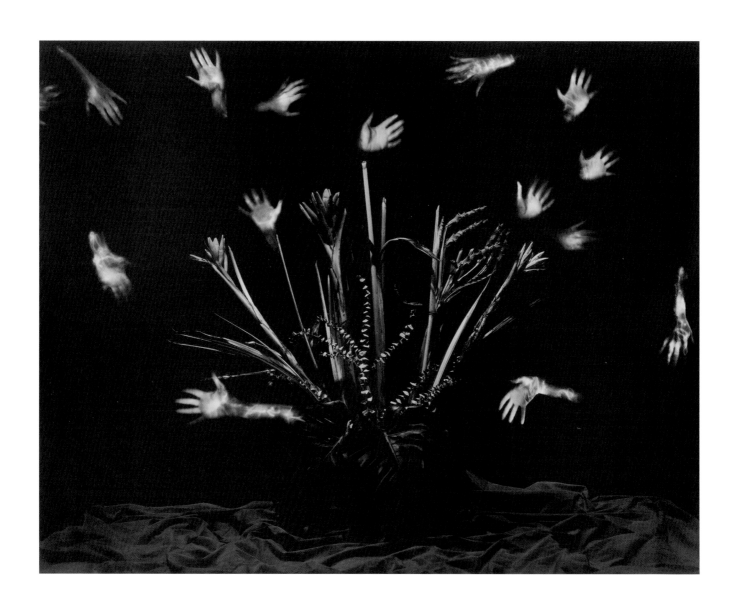

51. *Hands*, 1989 (negative), 1991 (print)

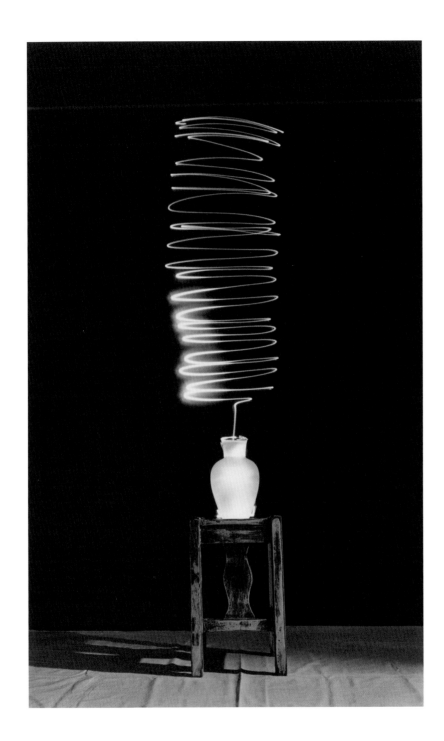

52. *Scribble #8*, 1987

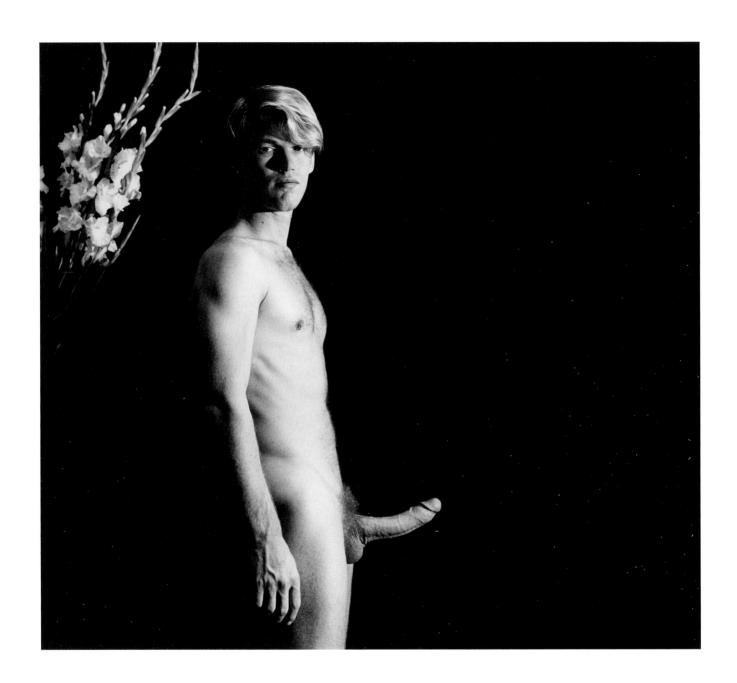

53. *Scott*, 1989 (negative), 1990 (print)

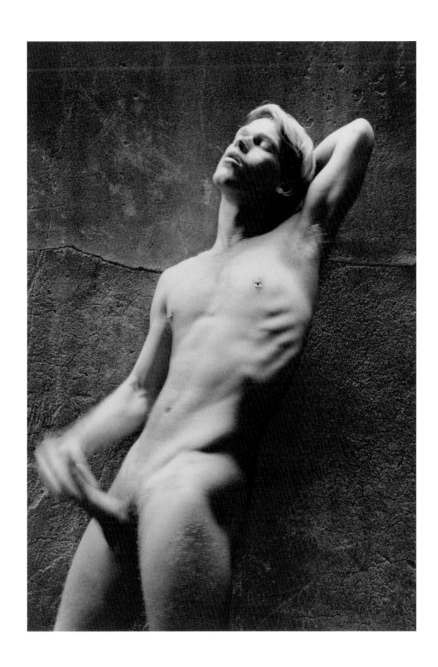

54. *Scott*, 1989

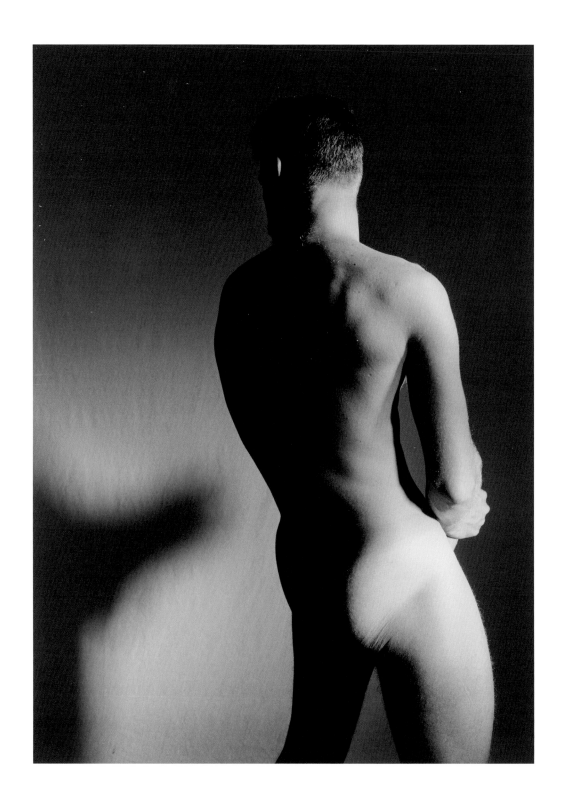

55. *Scott: Shadow Play*, 1990 (negative), 1991 (print)

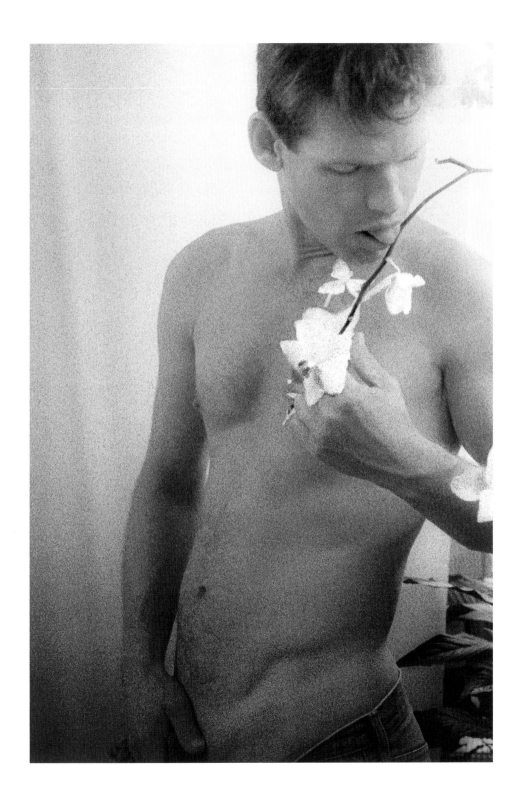

56. *Scott*, 1991 (negative), 2015 (print)

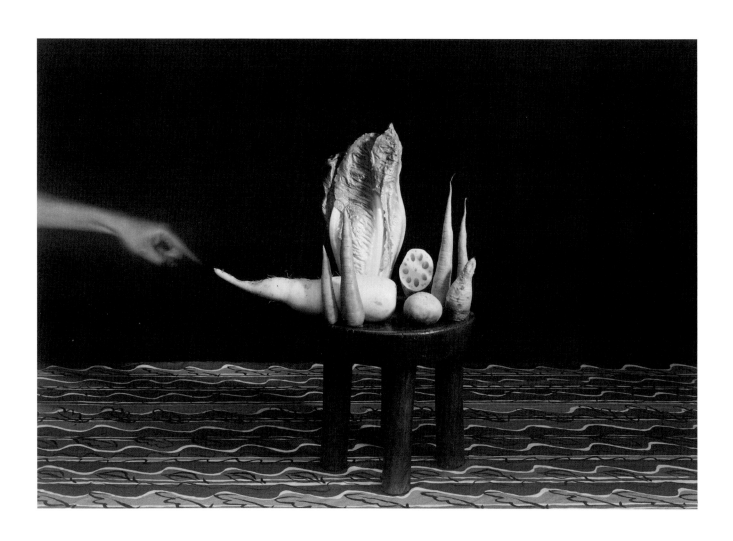

57. *Food for Thought: Organic Chinese Cabbage, Daikon, Turnips, Lotus Root, Carrots & Rutabaga*, April 29, 1992 (negative), 1994 (print)

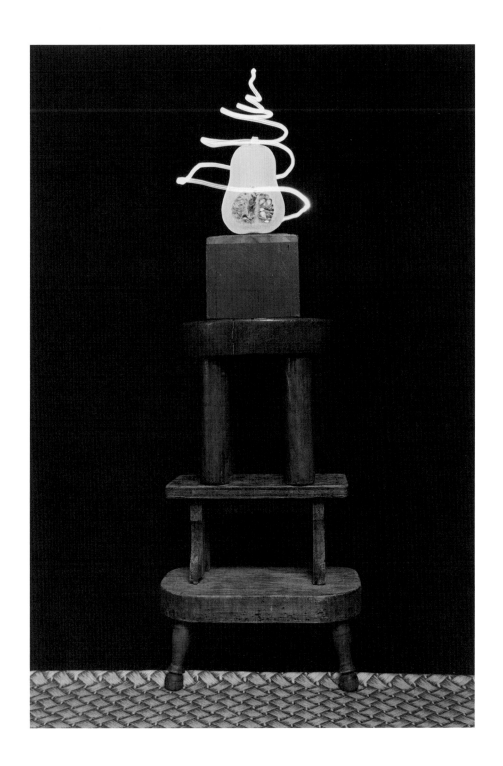

58. *Food for Thought: Organic Butternut Squash*, April 11, 1992 (negative), 1994 (print)

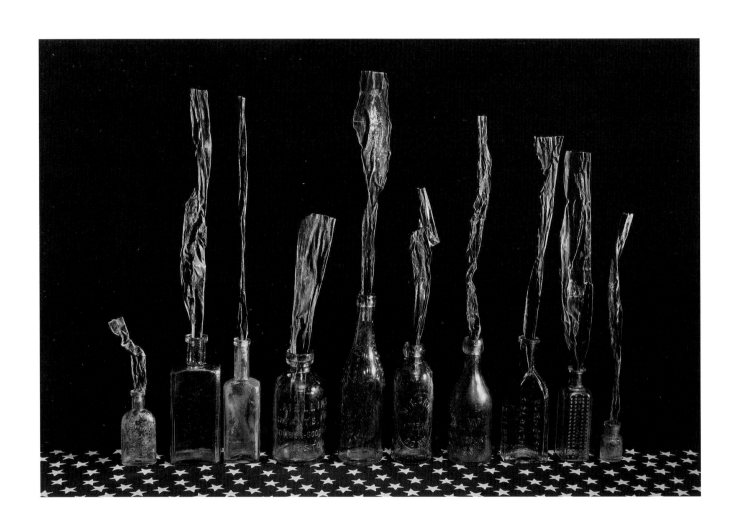

59. *Food for Thought: Wild Kombu in Bottles*, 1992 (negative), 1995 (print)

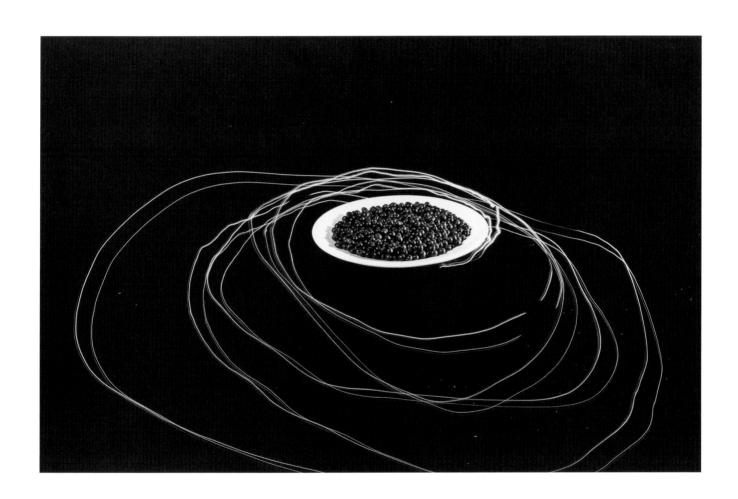

60. *Food for Thought: Organic Black Soy Beans*, April 7, 1992 (negative), 1994 (print)

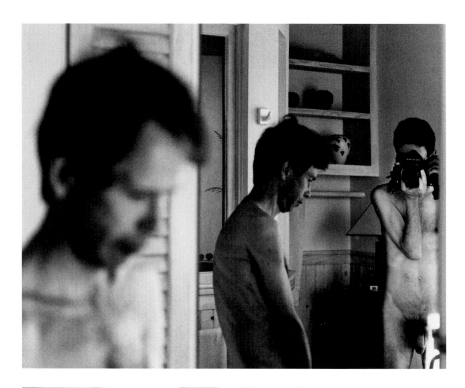

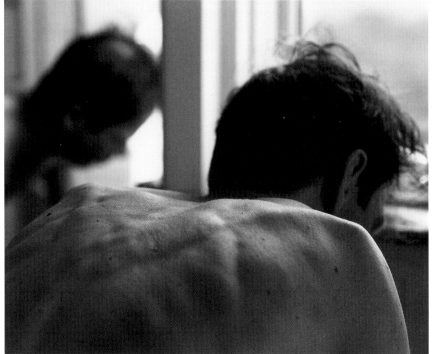

61. *Morning Ritual No. 27*, 1994 (negative), 1996 (print)
62. *Morning Ritual No. 15*, 1994 (negative), 1996 (print)

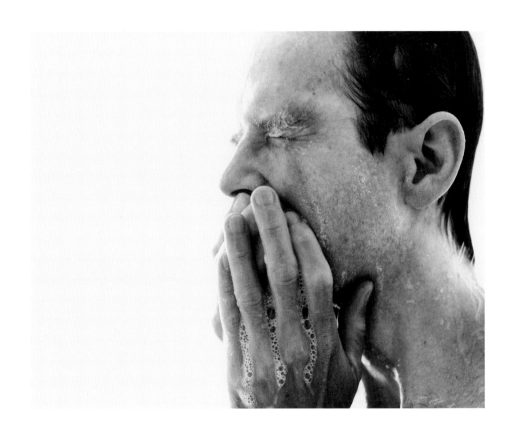

63. *Morning Ritual No. 6*, 1994

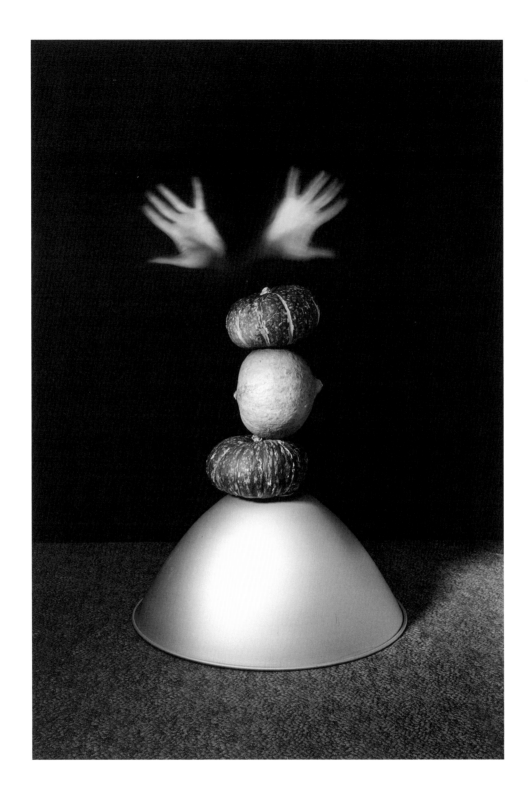

64. *Food for Thought: Organic Squash with Hands*, June 25, 1992 (negative), 1994 (print)

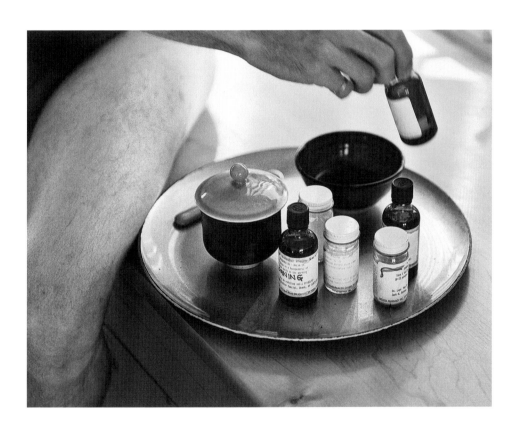

65. *Morning Ritual No. 30A*, 1994 (negative), 2015 (print)

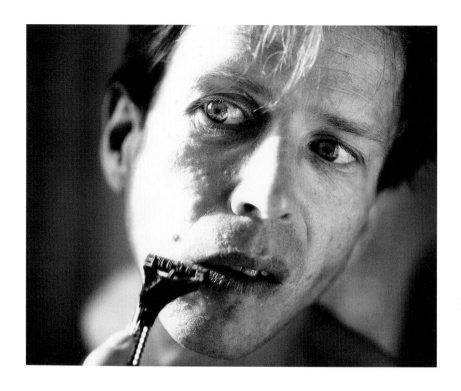

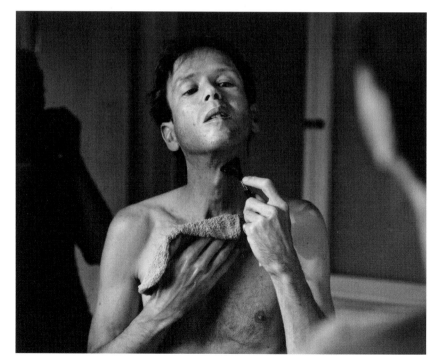

66. *Morning Ritual No. 1*, 1994 (negative), 1996 (print)
67. *Morning Ritual No. 12*, 1994 (negative), 1996 (print)

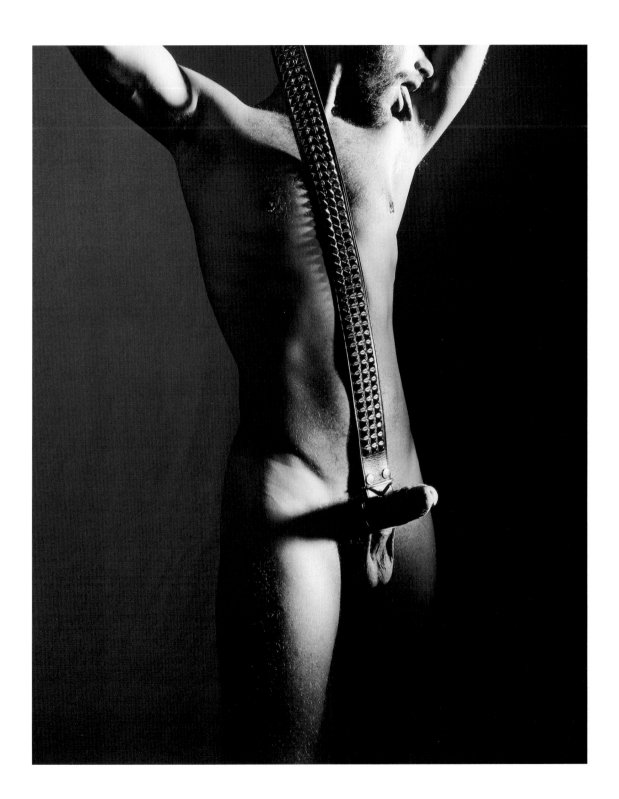

68. *Scott*, 1990 (negative), 1991 (print)

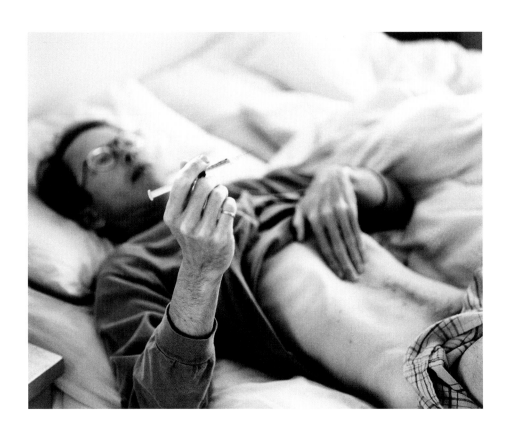

69. *Morning Ritual No. 29*, 1994 (negative), 1996 (print)

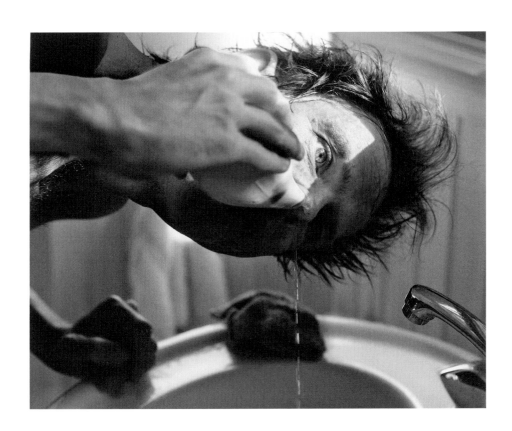

70. *Morning Ritual No. 4*, 1994 (negative), 1996 (print)

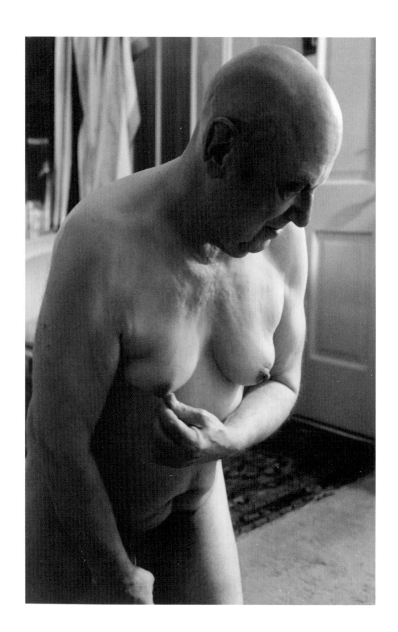

71. *Ellis St. Joseph, Beverly Hills,* 1989

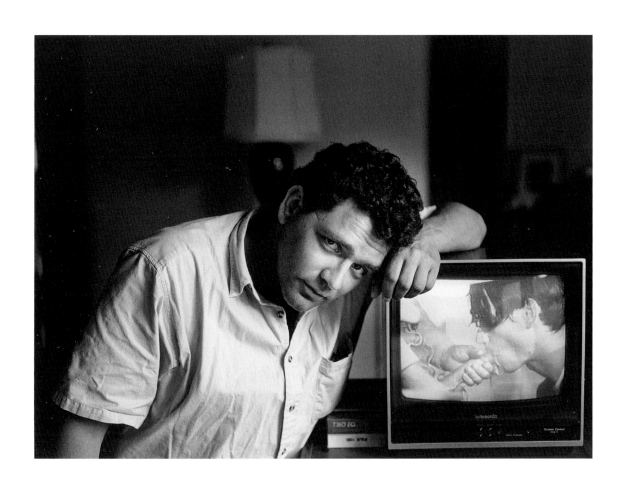

72. *Bernie & TV*, 1990

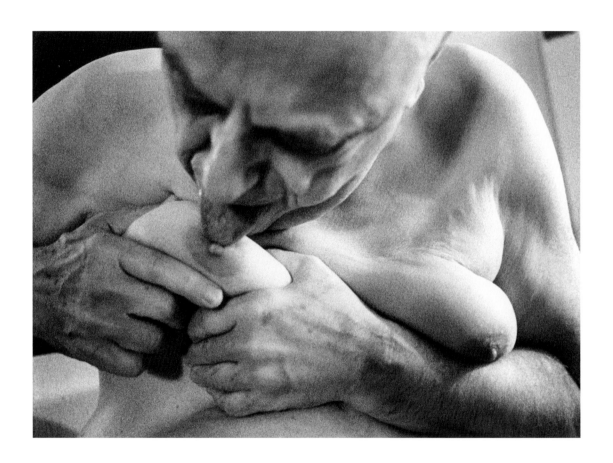

73. *Ellis St. Joseph, Beverly Hills,* 1989

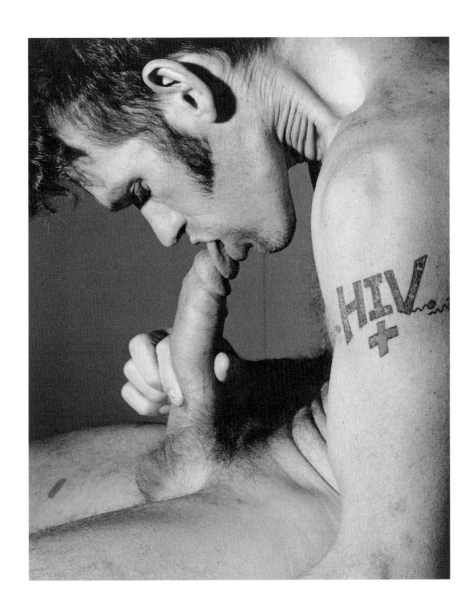

74. *Scott*, 1995

75. *Morning Ritual No. 10*, 1994 (negative), 1996 (print)

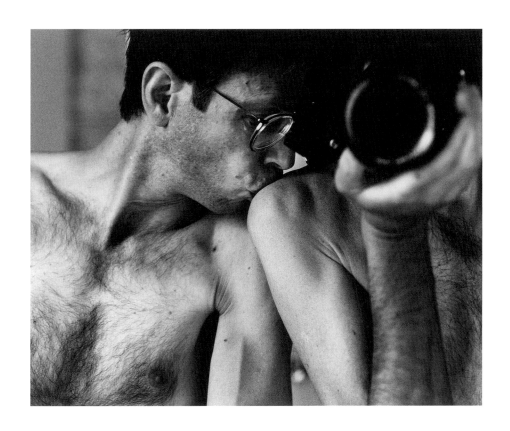

76. *Morning Ritual No. 28*, 1994 (negative), 1996 (print)

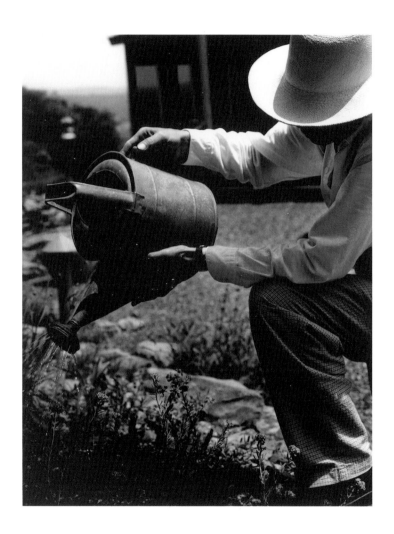

77. *Jack's Garden: Jack Watering*, 1996 (negative), 1997 (print)

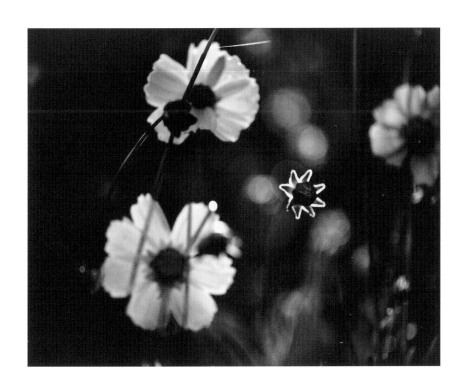

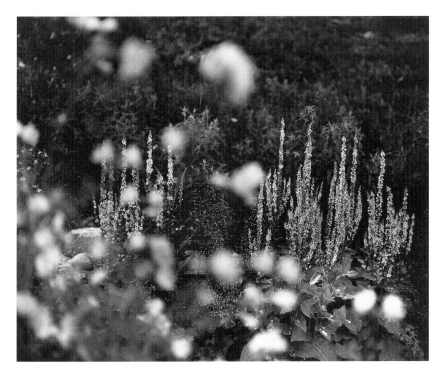

78. *Jack's Garden: Coreopsis Glowing Star*, 1996 (negative), 1997 (print)
79. *Jack's Garden: Mulleins and Mallows*, 1997

80. *Jack's Garden: Big Blue Stem Flowering*, 1997

81. *Morning Ritual No. 3*, 1994 (negative), 1996 (print)

82. *Morning Ritual No. 11*, 1994 (negative), 1996 (print)

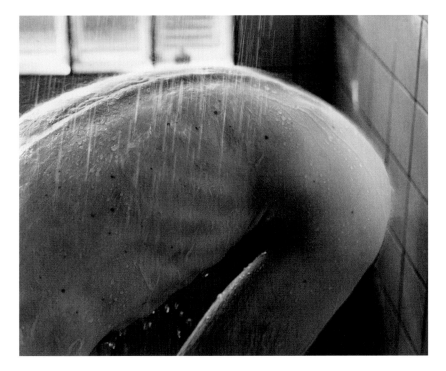

83. *Morning Ritual No. 33*, 1994 (negative), 1996 (print)
84. *Morning Ritual No. 9*, 1994 (negative), 1996 (print)

85. *Jack's Garden: Coreopsis at Sunset*, 1996 (negative), 1997 (print)
86. *Jack's Garden: Shirley Poppies*, 1997

87. *Jack's Garden: Leek Buds*, 1997

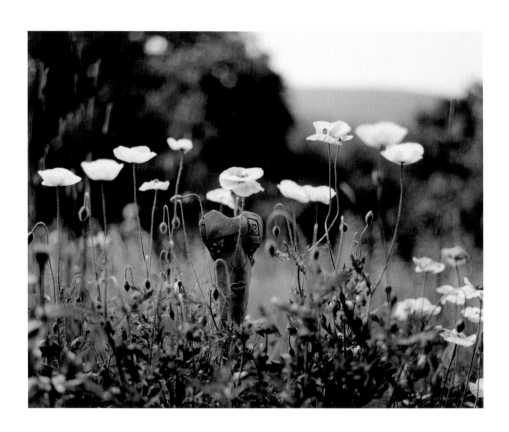

88. *Jack's Garden: Shirley Poppies and Ira's Garden Goddess*, 1997

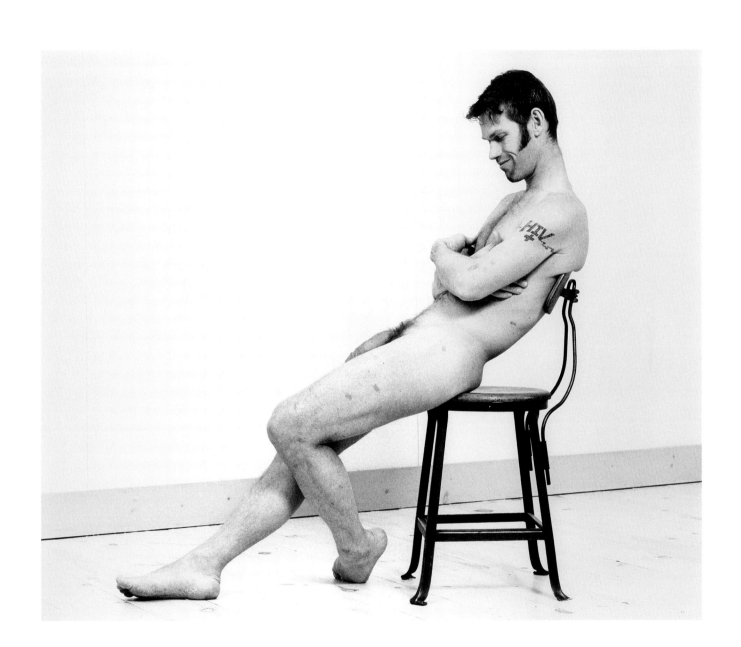

89. *Scott*, 1995 (negative), 1997 (print)

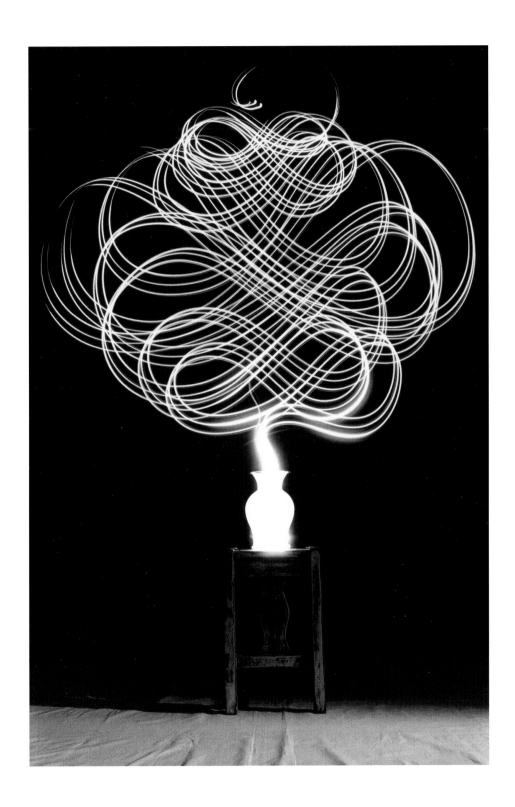

90. *Scribble #15*, 1987

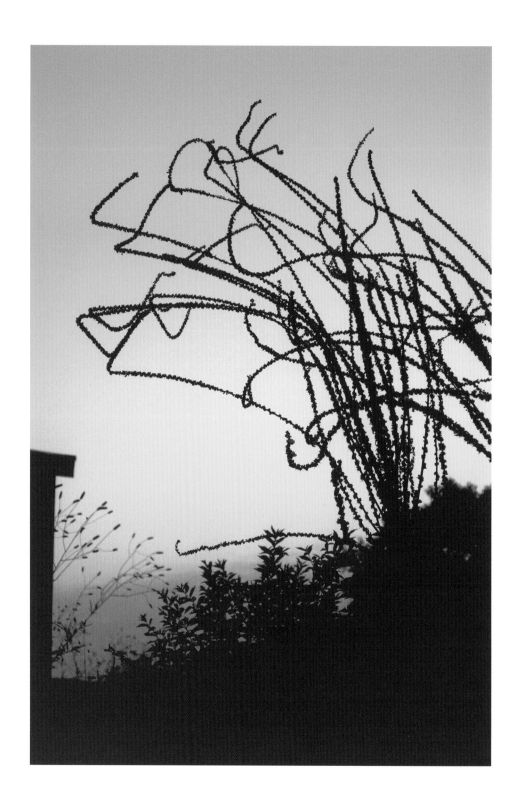

91. *On May Hill: Mullein Scribble*, 2007 (image file), 2015 (print)

92. *On May Hill: Maple Leaf Shadows*, 2006 (image file), 2015 (print)

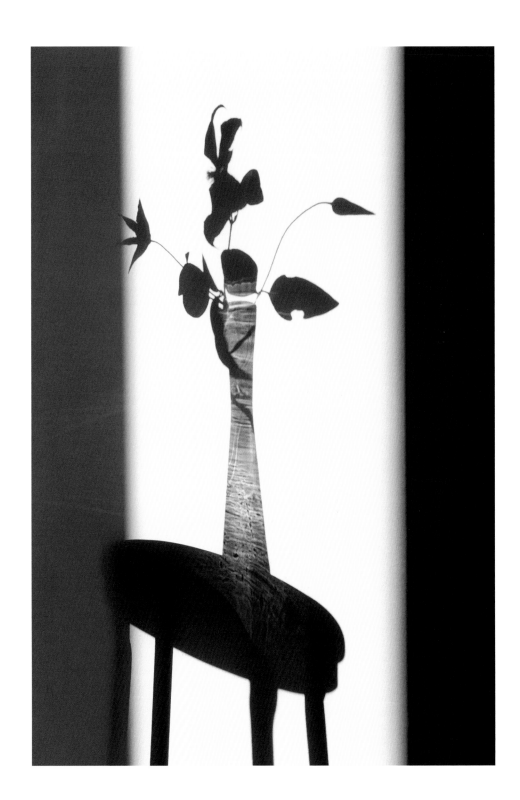

93. *ShadowLife 154 (Clematis)*, July 4, 2017 (image file), 2018 (print)

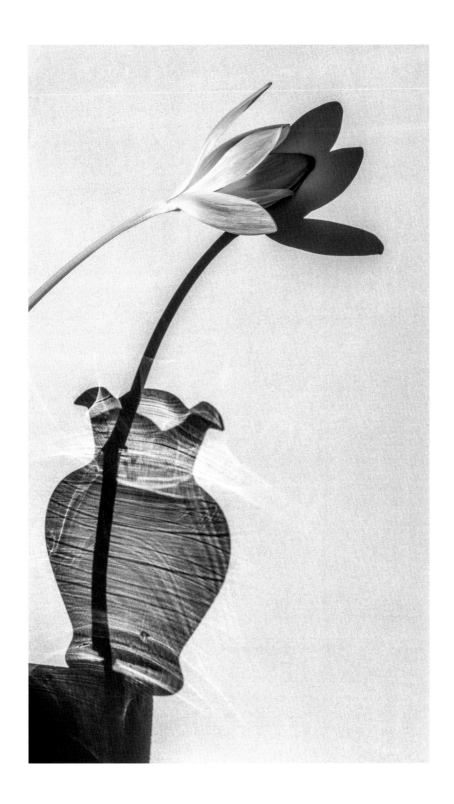

94. *ShadowLife 102 (Colchicum)*, September 25, 2016 (image file), 2018 (print)

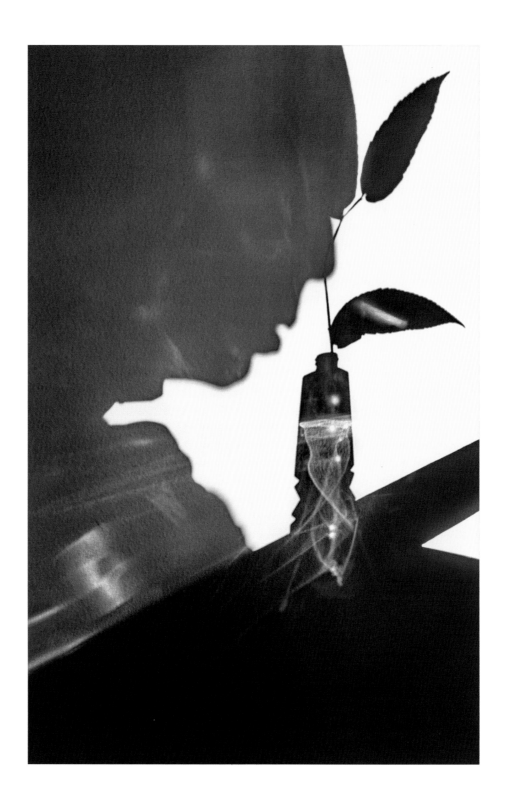

95. *ShadowLife 044 (Self)*, December 11, 2013 (image file), 2018 (print)

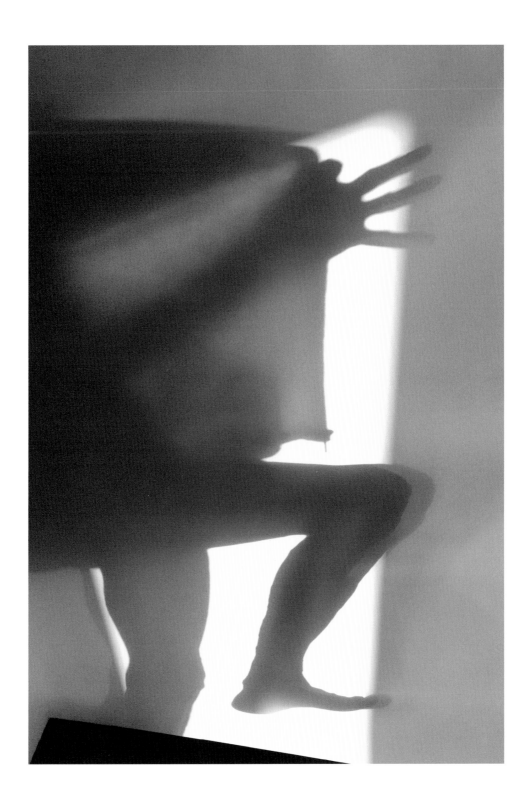

96. *ShadowLife 016 (Self)*, April 4, 2013 (image file), 2018 (print)

List of Plates

Page 1
Seth, 1985 (negative), 1986 (print)
Hand-colored gelatin silver print
15 ⅛ × 17 ¹⁵⁄₁₆ inches (38.4 × 45.5 cm)
Philadelphia Museum of Art. Gift of the artist, 2016-30-62

Page 2
Scribble #23, 1987 (negative), 1992 (print)
Hand-colored gelatin silver print
43 ⅜ × 29 ¹⁵⁄₁₆ inches (110.2 × 76 cm)
Philadelphia Museum of Art. Gift of the artist, 2016-30-118

Page 5
Scott, 1995 (negative), 1997 (print)
Pigment print
18 ¾ × 15 inches (47.6 × 38.1 cm)
Courtesy of the artist

Page 8
DC87 41 [S/M-Leather Contingent], 1987 (negative), 2018 (print)
Pigment print
5 ½ × 8 ¼ inches (14 × 21 cm)
Courtesy of the artist

Page 9 (top)
DC87 10 [Radical Faerie Contingent, including Marvelous Marvin (Marvin Dennis Moore, with sign), David Axel (talking with Marvelous Marvin), Harry Ugol (with Cernunnos shawl), and Oola (Ben Gardiner, with long beard)], 1987 (negative), 2018 (print)
Pigment print
5 ½ × 8 ¼ inches (14 × 21 cm)
Courtesy of the artist

Page 9 (bottom)
DC87 04 [Texas boys], 1987 (negative), 2018 (print)
Pigment print
5 ½ × 8 ¼ inches (14 × 21 cm)
Courtesy of the artist

Page 10 (top)
DC87 35 [Parade marshall and D.C. police], 1987 (negative), 2018 (print)
Pigment print
5 ½ × 8 ¼ inches (14 × 21 cm)
Courtesy of the artist

Page 10 (bottom)
DC87 48 [AIDSGATE poster by the Silence=Death Collective in response to Ronald Reagan refusing to acknowledge AIDS publicly], 1987 (negative), 2018 (print)
Pigment print
5 ½ × 8 ¼ inches (14 × 21 cm)
Courtesy of the artist

Page 11
DC87 03 [Sistah Boom Contingent, Germaine Quiter, drummer], 1987 (negative), 2018 (print)
Pigment print
5 ½ × 8 ¼ inches (14 × 21 cm)
Courtesy of the artist

Plate 1
Garden Series #26, 1979 (negative), 1985 (print)
Hand-colored gelatin silver print
15 ¹⁵⁄₁₆ × 19 ⅞ inches (40.5 × 50.5 cm)
Philadelphia Museum of Art. Gift of the artist, 2016-30-75

Plate 2
Susan, Blue Dress, 1973
Hand-colored gelatin silver print
2 ⁵⁄₁₆ × 11 ⅝ inches (5.9 × 29.5 cm)
Philadelphia Museum of Art. Gift of the artist, 2016-30-17

Plate 3
Wink: Self, Memorial Hall, Philadelphia, 1974
Hand-colored gelatin silver print
2 ⁵⁄₁₆ × 12 ¹⁄₁₆ inches (5.9 × 30.7 cm)
Philadelphia Museum of Art. Gift of the artist, 2016-30-12

Plate 4
Susan, Green Dress, 1973
Hand-colored gelatin silver print
11⅞ × 2⅜ inches (30.2 × 6 cm)
Philadelphia Museum of Art. Gift of the artist, 2016-30-16

Plate 5
Seven Photographers Seventy-Five,
1975 (negative), 2015 (print)
Pigment print
4½ × 55 inches (11.5 × 139.7 cm)
Philadelphia Museum of Art. Gift of the artist, 2016-30-29

Plate 6
Head and Hand, Jessie, 1970 (negative),
2015 (print)
Pigment print
4½ × 53⅞ inches (11.4 × 136.9 cm)
Philadelphia Museum of Art. Gift of the artist, 2016-30-26

Plate 7
May Sam & Lynn, 1970 (negative),
2015 (print)
Pigment print
4½ × 27 inches (11.4 × 68.6 cm)
Philadelphia Museum of Art. Gift of the artist, 2016-30-22

Plate 8
High Adventure: Wandering the City with Terry (on "Franklin's Footpath" by Gene Davis), 1973 (color transparency),
2015 (print)
Pigment print
4 × 19⁹⁄₁₆ inches (10.1 × 49.7 cm)
Philadelphia Museum of Art. Gift of the artist, 2017-144-30

Plate 9
Gay Girl / Straight Bar: 11th Street, Philadelphia, 1973 (color transparency),
2015 (print)
Pigment print
4 × 18⅜ inches (10.1 × 46.7 cm)
Philadelphia Museum of Art. Gift of the artist, 2017-144-35

Plate 10
Susan on Shelf, 1974 (negatives), 1975
(prints and object)
Hand-colored gelatin silver prints,
Plexiglass, painted wood
9 × 18 × 1⅜ inches (22.8 × 45.7 × 3.5 cm)
Philadelphia Museum of Art. Gift of the artist, 2016-30-121

Plate 11
Unphotograph Three – Joe & Chris, March 22, 1974 (negative), c. 1974–75 (print)
Hand-colored gelatin silver print
10¼ × 6½ inches (26.1 × 16.5 cm)
Philadelphia Museum of Art. Gift of the artist, 2016-30-7

Plate 12
Unphotograph One – Edith Neff, February 10, 1974 (negative), c. 1974–75 (print)
Hand-colored gelatin silver print
9¹⁵⁄₁₆ × 6⁹⁄₁₆ inches (25.3 × 16.6 cm)
Philadelphia Museum of Art. Gift of the artist, 2016-30-6

Plate 13
Hazy Day Beach: Beach Haven, 1975
(color transparency), 2016 (print)
Pigment print
4 × 19⁵⁄₁₆ inches (10.1 × 49 cm)
Philadelphia Museum of Art. Gift of the artist, 2017-144-9

Plate 14
Unphotograph Five – Atlantic City, May 26, 1974 (negative), c. 1974–75 (print)
Hand-colored gelatin silver print
6³⁄₁₆ × 9¼ inches (15.7 × 23.5 cm)
Philadelphia Museum of Art. Gift of the artist, 2016-30-8

Plate 15
Self-Portrait #6, Pissing, 1977 (negative),
c. 1996 (print)
Gelatin silver print
12⅞ × 9¹⁵⁄₁₆ inches (32.7 × 25.3 cm)
Philadelphia Museum of Art. Gift of the artist, 2016-30-38

Plate 16
Specimen #14, 1978
Gelatin silver print
19¹⁵⁄₁₆ × 16 inches (50.6 × 40.6 cm)
Philadelphia Museum of Art. Gift of the artist, 2016-30-81

Plate 17
Barry in Rocker, 1979
Gelatin silver print
14 × 19⅞ inches (35.6 × 50.5 cm)
Philadelphia Museum of Art. Gift of the artist, 2016-30-40

Plate 18
Garden Series #1, 1979
Hand-colored gelatin silver print
15⅞ × 19¹³⁄₁₆ inches (40.3 × 50.3 cm)
Philadelphia Museum of Art. Gift of Hope and Michael Proper, 2013-139-1

Plate 19
Garden Series #3, 1979
Hand-colored gelatin silver print
15⅞ × 19¹³⁄₁₆ inches (40.3 × 50.3 cm)
Philadelphia Museum of Art. Gift of Hope and Michael Proper, 2013-139-3

Plate 20
Angelo in Robe, 1979 (negative),
1995 (print)
Gelatin silver print
17⁹⁄₁₆ × 22⅜ inches (44.6 × 56.8 cm)
Philadelphia Museum of Art. Purchased with the Julius Bloch Memorial Fund created by Benjamin D. Bernstein and the Leo Model Foundation Curatorial Discretionary Fund, 2010-81-1

Plate 21
Angelo on the Roof, 1979 (negative),
1995 (print)
Gelatin silver print
15½ × 22⅜ inches (39.4 × 56.8 cm)
Philadelphia Museum of Art. Gift of the artist, 2010-80-1

Plate 22
Garden Series #4, 1979
Hand-colored gelatin silver print
15 ¹³⁄₁₆ × 19 ¾ inches (40.2 × 50.2 cm)
Philadelphia Museum of Art. Gift of Hope and Michael Proper, 2013-139-4

Plate 23
Provincetown, July 1980 (negative),
1983 (print)
Gelatin silver print
12 ¹¹⁄₁₆ × 18 ³⁄₁₆ inches (32.2 × 46.2 cm)
Philadelphia Museum of Art. Gift of the artist, 2016-30-41

Plate 24
Specimen #18, 1980
Hand-colored gelatin silver print
19 ¾ × 15 ¾ inches (50.2 × 40 cm)
Philadelphia Museum of Art. Gift of Adam Kaufman, 1981-5-1

Plate 25
Self 11:98, 1981 (negative), 1985 (print)
Gelatin silver print
14 ¼ × 18 ⁷⁄₁₆ inches (36.2 × 46.9 cm)
Philadelphia Museum of Art. Gift of the artist, 2016-30-43

Plate 26
Specimen #1, 1981
Hand-colored gelatin silver print
19 ¹⁵⁄₁₆ × 15 ¹⁵⁄₁₆ inches (50.7 × 40.5 cm)
Philadelphia Museum of Art. Gift of the artist, 2016-30-80

Plate 27
Boy Dream, 1981 (negative), 1989 (print)
Gelatin silver print
18 ⁹⁄₁₆ × 30 inches (47.2 × 76.2 cm)
Philadelphia Museum of Art. Gift of the artist, 2016-30-116

Plate 28
Specimen (unnumbered), 1981
Gelatin silver print
19 ⅞ × 15 ¹⁵⁄₁₆ inches (50.5 × 40.5 cm)
Philadelphia Museum of Art. Gift of the artist, 2016-30-84

Plate 29
Wayne at the Window, 1980 (negative),
1981 (print)
Hand-colored gelatin silver print
15 ³⁄₁₆ × 19 ⅛ inches (38.6 × 48.6 cm)
Philadelphia Museum of Art. Gift of the artist, 2016-30-48

Plate 30
Self-Portrait with Orchid, 1982
Hand-colored gelatin silver print
12 ⁵⁄₁₆ × 18 ⅜ inches (31.3 × 46.6 cm)
Philadelphia Museum of Art. Gift of the artist, 2016-30-50

Plate 31
The Window, 1982 (negative), 1995 (print)
Gelatin silver print
22 ⁷⁄₁₆ × 15 inches (57 × 38.1 cm)
Philadelphia Museum of Art. Gift of the artist, 2016-30-45

Plate 32
Renato's Arc, 1983 (negative), 1984 (print)
Hand-colored gelatin silver print
12 ⅝ × 18 ⅝ inches (32.1 × 47.3 cm)
Courtesy of the artist

Plate 33
Roots, 1982 (negative), 1985 (print)
Hand-colored gelatin silver print
12 ⁷⁄₁₆ × 18 ³⁄₁₆ inches (31.6 × 46.2 cm)
Philadelphia Museum of Art. Gift of Hope and Michael Proper, 2004-207-22

Plate 34
Tulips Outlined in Red Light (Sketch), 1982
(negative), 1983 (print)
Hand-colored gelatin silver print
9 × 6 inches (22.8 × 15.2 cm)
Philadelphia Museum of Art. Gift of the artist, 2016-30-69

Plate 35
Dragon Boy, Renato, 1983
Hand-colored gelatin silver print
12 ¹¹⁄₁₆ × 18 ⅜ inches (32.2 × 46.6 cm)
Philadelphia Museum of Art. Gift of the artist, 2016-30-51

Plate 36
Landscape #21, 1985
Hand-colored gelatin silver print
19 ¾ × 15 ¹³⁄₁₆ inches (50.1 × 40.2 cm)
Philadelphia Museum of Art. Gift of the artist, 2016-30-73

Plate 37
Vaughn Stubbs, Fire Island, 1985 (negative),
1987 (print)
Gelatin silver print
12 ⅛ × 18 ¼ inches (30.8 × 46.3 cm)
Philadelphia Museum of Art. Gift of the artist, 2016-30-56

Plate 38
Landscape #10, 1985
Hand-colored gelatin silver print
15 ¹⁵⁄₁₆ × 19 ⅞ inches (40.5 × 50.5 cm)
Courtesy of the artist

Plate 39
Landscape #33, 1985 (negative),
1986 (print)
Hand-colored gelatin silver print
16 ¹⁵⁄₁₆ × 20 ⅞ inches (43 × 53 cm)
Philadelphia Museum of Art. Gift of the artist, 2016-30-74

Plate 40
In Fact We Laugh with the Idea of Death #3,
1986 (negative), 1987 (print)
Hand-colored gelatin silver print
16 × 14 ⅛ inches (40.7 × 35.9 cm)
Philadelphia Museum of Art. Gift of the artist, 2016-30-78

Plate 41
In Fact We Laugh with the Idea of Death,
1986
Gelatin silver print
19 ¹⁵⁄₁₆ × 15 ⅞ inches (50.6 × 40.4 cm)
Philadelphia Museum of Art. Gift of the artist, 2016-30-79

Plate 42
Bernard, Grady & Me, 1986 (negative),
1988 (print)
Hand-colored gelatin silver print
14 × 13 ⅞ inches (35.6 × 35.3 cm)
Courtesy of the artist

Plate 43
Scribble #2, 1987 (negative), 1988 (print)
Hand-colored gelatin silver print
17⅞ × 12⁵⁄₁₆ inches (45.4 × 31.2 cm)
Courtesy of the artist

Plate 44
Floating Landscape #3, 1986 (negative),
1987 (print)
Hand-colored gelatin silver print
19¹³⁄₁₆ × 15⅞ inches (50.4 × 40.4 cm)
Philadelphia Museum of Art. Gift of the
artist, 2016-30-77

Plate 45
Scribble #17, 1987 (negative), 1988 (print)
Hand-colored gelatin silver print
17⅝ × 10¹⁵⁄₁₆ inches (44.7 × 27.8 cm)
Courtesy of the artist

Plate 46
Shadow Play, 1987 (negative), 1991 (print)
Hand-colored gelatin silver print
29 × 20³⁄₁₆ inches (73.7 × 51.3 cm)
Philadelphia Museum of Art. Gift of the
artist, 2016-30-120

Plate 47
Scott, 1991 (negative), 2015 (print)
Pigment print, 2015
13⁹⁄₁₆ × 20¹⁄₁₆ inches (34.5 × 50.9 cm)
Philadelphia Museum of Art. Gift of the
artist, 2016-30-107

Plate 48
Scribble #6, Feet, 1987
Hand-colored gelatin silver print
18⅞ × 12½ inches (48 × 31.7 cm)
Philadelphia Museum of Art. Gift of the
artist, 2016-30-53

Plate 49
Seth, 1987 (negative), c. 1991 (print)
Gelatin silver print
29 × 20¹⁄₁₆ inches (73.6 × 50.9 cm)
Philadelphia Museum of Art. Gift of the
artist, 2016-30-119

Plate 50
Anthurium Display, 1988 (negative),
1995 (print)
Gelatin silver print
15⅞ × 22⁷⁄₁₆ inches (40.4 × 57 cm)
Philadelphia Museum of Art. Gift of the
artist, 2016-30-58

Plate 51
Hands, 1989 (negative), 1991 (print)
Hand-colored gelatin silver print
30½ × 39¼ inches (77.4 × 99.7 cm)
Philadelphia Museum of Art. Gift of the
artist, 2016-30-117

Plate 52
Scribble #8, 1987
Hand-colored gelatin silver print
15⅞ × 10¹⁵⁄₁₆ inches (40.4 × 27.8 cm)
Philadelphia Museum of Art. Gift of the
artist, 2016-30-54

Plate 53
Scott, 1989 (negative), 1990 (print)
Gelatin silver print
15 × 16⅞ inches (38.1 × 42.8 cm)
Philadelphia Museum of Art. Gift of the
artist, 2016-30-97

Plate 54
Scott, 1989
Gelatin silver print
9 × 6³⁄₁₆ inches (22.9 × 15.7 cm)
Philadelphia Museum of Art. Gift of the
artist, 2016-30-103

Plate 55
Scott: Shadow Play, 1990 (negative),
1991 (print)
Gelatin silver print
18⅝ × 13½ inches (47.3 × 34.3 cm)
Philadelphia Museum of Art. Gift of the
artist, 2016-30-100

Plate 56
Scott, 1991 (negative), 2015 (print)
Pigment print
20¹⁄₁₆ × 13⁷⁄₁₆ inches (50.9 × 34.2 cm)
Philadelphia Museum of Art. Gift of the
artist, 2016-30-108

Plate 57
*Food for Thought: Organic Chinese Cabbage,
Daikon, Turnips, Lotus Root, Carrots &
Rutabaga*, April 29, 1992 (negative),
1994 (print)
Gelatin silver print
15⁷⁄₁₆ × 22⁹⁄₁₆ inches (39.2 × 57.3 cm)
Philadelphia Museum of Art. Gift of the
artist, 2016-30-91

Plate 58
Food for Thought: Organic Butternut Squash,
April 11, 1992 (negative), 1994 (print)
Gelatin silver print
22½ × 15¹⁄₁₆ inches (57.2 × 38.2 cm)
Philadelphia Museum of Art. Gift of the
artist, 2016-30-90

Plate 59
Food for Thought: Wild Kombu in Bottles,
1992 (negative), 1995 (print)
Gelatin silver print
15¹⁄₁₆ × 22⁹⁄₁₆ inches (38.2 × 57.3 cm)
Philadelphia Museum of Art. Gift of the
artist, 2016-30-93

Plate 60
Food for Thought: Organic Black Soy Beans,
April 7, 1992 (negative), 1994 (print)
Gelatin silver print
14⁷⁄₁₆ × 22½ inches (36.7 × 57.2 cm)
Philadelphia Museum of Art. Gift of the
artist, 2016-30-88

Plate 61
Morning Ritual No. 27, 1994 (negative),
1996 (print)
Gelatin silver print
4¹⁵⁄₁₆ × 6¼ inches (12.5 × 15.9 cm)
Philadelphia Museum of Art. Gift of the
artist, 2016-30-115(27)

Plate 62
Morning Ritual No. 15, 1994 (negative),
1996 (print)
Gelatin silver print
5 × 6³⁄₁₆ inches (12.7 × 15.7 cm)
Philadelphia Museum of Art. Gift of the
artist, 2016-30-115(15)

Plate 63
Morning Ritual No. 6, 1994
Gelatin silver print
5 × 6³⁄₁₆ inches (12.7 × 15.7 cm)
Philadelphia Museum of Art. Gift of the
artist, 2016-30-115(6)

Plate 64
*Food for Thought: Organic Squash with
Hands*, June 25, 1992 (negative),
1994 (print)
Gelatin silver print
22½ × 15⁵⁄₁₆ inches (57.2 × 38.9 cm)
Philadelphia Museum of Art. Gift of the
artist, 2016-30-95

Plate 65
Morning Ritual No. 30A, 1994 (negative),
2015 (print)
Pigment print
5 × 6⅜ inches (12.7 × 16.2 cm)
Philadelphia Museum of Art. Gift of the
artist, 2016-30-115(31)

Plate 66
Morning Ritual No. 1, 1994 (negative),
1996 (print)
Gelatin silver print
5 × 6¼ inches (12.7 × 15.9 cm)
Philadelphia Museum of Art. Gift of the
artist, 2016-30-115(1)

Plate 67
Morning Ritual No. 12, 1994 (negative),
1996 (print)
Gelatin silver print
5 × 6³⁄₁₆ inches (12.7 × 15.7 cm)
Philadelphia Museum of Art. Gift of the
artist, 2016-30-115(12)

Plate 68
Scott, 1990 (negative), 1991 (print)
Gelatin silver print
18¹³⁄₁₆ × 15 inches (47.8 × 38.1 cm)
Courtesy of the artist

Plate 69
Morning Ritual No. 29, 1994 (negative),
1996 (print)
Gelatin silver print
5 × 6³⁄₁₆ inches (12.7 × 15.7 cm)
Philadelphia Museum of Art. Gift of the
artist, 2016-30-115(29)

Plate 70
Morning Ritual No. 4, 1994 (negative),
1996 (print)
Gelatin silver print
5 × 6³⁄₁₆ inches (12.7 × 15.7 cm)
Philadelphia Museum of Art. Gift of the
artist, 2016-30-115(4)

Plate 71
Ellis St. Joseph, Beverly Hills, 1989
Gelatin silver print
9 × 5¹³⁄₁₆ inches (22.8 × 14.7 cm)
Philadelphia Museum of Art. Gift of the
artist, 2016-30-60

Plate 72
Bernie & TV, 1990
Gelatin silver print
6¹⁵⁄₁₆ × 9⁷⁄₁₆ inches (17.7 × 24 cm)
Philadelphia Museum of Art. Gift of the
artist, 2016-30-59

Plate 73
Ellis St. Joseph, Beverly Hills, 1989
Gelatin silver print
6⁷⁄₁₆ × 9 inches (16.3 × 22.8 cm)
Philadelphia Museum of Art. Gift of the
artist, 2016-30-61

Plate 74
Scott, 1995
Gelatin silver print
7¹¹⁄₁₆ × 6³⁄₁₆ inches (19.6 × 15.7 cm)
Philadelphia Museum of Art. Gift of the
artist, 2016-30-104

Plate 75
Morning Ritual No. 10, 1994 (negative),
1996 (print)
Gelatin silver print
5 × 6³⁄₁₆ inches (12.7 × 15.7 cm)
Philadelphia Museum of Art. Gift of the
artist, 2016-30-115(10)

Plate 76
Morning Ritual No. 28, 1994 (negative),
1996 (print)
Gelatin silver print
5 × 6³⁄₁₆ inches (12.7 × 15.7 cm)
Philadelphia Museum of Art. Gift of the
artist, 2016-30-115(28)

Plate 77
Jack's Garden: Jack Watering, 1996
(negative), 1997 (print)
Gelatin silver print
6⅜ × 4¹⁵⁄₁₆ inches (16.2 × 12.5 cm)
Philadelphia Museum of Art. Gift of the
artist, 2016-30-114(1)

Plate 78
Jack's Garden: Coreopsis Glowing Star,
1996 (negative), 1997 (print)
Gelatin silver print
4¹⁵⁄₁₆ × 6³⁄₁₆ inches (12.5 × 15.7 cm)
Philadelphia Museum of Art. Gift of the
artist, 2016-30-114(6)

Plate 79
Jack's Garden: Mulleins and Mallows, 1997
Gelatin silver print
5 × 6⅛ inches (12.7 × 15.6 cm)
Philadelphia Museum of Art. Gift of the
artist, 2016-30-114(23)

Plate 80
Jack's Garden: Big Blue Stem Flowering, 1997
Gelatin silver print
4⅞ × 6⅛ inches (12.4 × 15.6 cm)
Philadelphia Museum of Art. Gift of the
artist, 2016-30-114(20)

Plate 81
Morning Ritual No. 3, 1994 (negative),
1996 (print)
Gelatin silver print
5 × 6¼ inches (12.7 × 15.9 cm)
Philadelphia Museum of Art. Gift of the
artist, 2016-30-115(3)

Plate 82
Morning Ritual No. 11, 1994 (negative),
1996 (print)
Gelatin silver print
6¼ × 4¹⁵⁄₁₆ inches (15.9 × 12.5 cm)
Philadelphia Museum of Art. Gift of the
artist, 2016-30-115(11)

Plate 83
Morning Ritual No. 33, 1994 (negative),
1996 (print)
Gelatin silver print
5 × 6³⁄₁₆ inches (12.7 × 15.7 cm)
Philadelphia Museum of Art. Gift of the
artist, 2016-30-115(35)

Plate 84
Morning Ritual No. 9, 1994 (negative),
1996 (print)
Gelatin silver print
5 × 6³⁄₁₆ inches (12.7 × 15.7 cm)
Philadelphia Museum of Art. Gift of the
artist, 2016-30-115(9)

Plate 85
Jack's Garden: Coreopsis at Sunset,
1996 (negative), 1997 (print)
Gelatin silver print
4⅞ × 6¼ inches (12.4 × 15.9 cm)
Philadelphia Museum of Art. Gift of the
artist, 2016-30-114(2)

Plate 86
Jack's Garden: Shirley Poppies, 1997
Gelatin silver print
4¹³⁄₁₆ × 6⅛ inches (12.2 × 15.6 cm)
Philadelphia Museum of Art. Gift of the
artist, 2016-30-114(19)

Plate 87
Jack's Garden: Leek Buds, 1997
Gelatin silver print
6³⁄₁₆ × 4⅞ inches (15.7 × 12.4 cm)
Philadelphia Museum of Art. Gift of the
artist, 2016-30-114(24)

Plate 88
*Jack's Garden: Shirley Poppies and Ira's
Garden Goddess*, 1997
Gelatin silver print
4⅞ × 6⅛ inches (12.4 × 15.6 cm)
Philadelphia Museum of Art. Gift of the
artist, 2016-30-114(14)

Plate 89
Scott, 1995 (negative), 1997 (print)
Gelatin silver print
15¹⁄₁₆ × 17¹⁵⁄₁₆ inches (38.2 × 45.5 cm)
Philadelphia Museum of Art. Gift of the
artist, 2016-30-102

Plate 90
Scribble #15, 1987
Gelatin silver print
22¼ × 14⅞ inches (56.5 × 37.8 cm)
Courtesy of the artist

Plate 91
On May Hill: Mullein Scribble, 2007
(image file), 2015 (print)
Pigment print
20¹⁄₁₆ × 13⁵⁄₁₆ inches (50.9 × 33.8 cm)
Philadelphia Museum of Art. Gift of the
artist, 2016-30-111

Plate 92
On May Hill: Maple Leaf Shadows, 2006
(image file), 2015 (print)
Pigment print
13⁵⁄₁₆ × 20¹⁄₁₆ inches (33.8 × 50.9 cm)
Courtesy of the artist

Plate 93
ShadowLife 154 (Clematis), July 4, 2017
(image file), 2018 (print)
Pigment print
17 × 11⅜ inches (43.2 × 28.9 cm)
Courtesy of the artist

Plate 94
ShadowLife 102 (Colchicum), September 25,
2016 (image file), 2018 (print)
Pigment print
17 × 9¹³⁄₁₆ inches (43.2 × 24.9 cm)
Courtesy of the artist

Plate 95
ShadowLife 044 (Self), December 11, 2013
(image file), 2018 (print)
Pigment print
23 × 15 inches (58.4 × 38.1 cm)
Courtesy of the artist

Plate 96
ShadowLife 016 (Self), April 4, 2013
(image file), 2018 (print)
Pigment print
23 × 15¾ inches (58.4 × 40 cm)
Courtesy of the artist

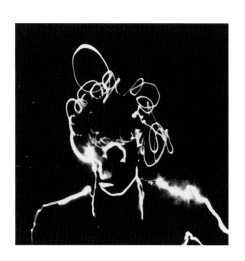

Acknowledgments

Many colleagues, friends, and new acquaintances helped make this book possible. First and foremost I thank David Lebe and Jack Potter for their generosity, openness, intelligent conversation, and friendship. Richard Kagan first introduced me to David Lebe's work in 2009. My essay benefited from his insightful 1994 interview with the artist and from my own interview with Kagan in the summer of 2018. Other interview subjects generously shared their memories and insights about David. Their voices are critically important to my essay: Paul Cava, Barbara Crane, Alan and Linda Eastman, Catherine Edelman, Seth Eisen, Jane Futcher, Cusie Pfeifer, Joan Redmond, Thomas Scott Tucker, Susan Welchman, Bernard Welt, and Carlton Willers.

At the Philadelphia Museum of Art, Innis Howe Shoemaker and John Ittmann granted me the time necessary to complete this publication. Colleagues and fellow photo historians Amanda Bock, Samuel Ewing, and Nathaniel Stein provided valuable feedback and insight at important stages of the project. Tyler Shine catalogued most of the photographs in this volume. His thoughtfulness about David Lebe's art and other subjects helped shape my thinking about the project. Our Publishing department has overseen this project with great sensitivity. My thanks to Katie Reilly and Rich Bonk. Dave Updike edited the text with surgical skill and real understanding of David's art and its context. Roy Brooks of Fold Four design studio wonderfully captured the artist's sensibility in his design of the book.

Jessica Johnston and Tate Shaw of the Visual Studies Workshop in Rochester, New York, graciously opened the Barbara Blondeau Archive for review and were helpful with myriad follow-up requests. In Philadelphia, John Anderies of the John J. Wilcox, Jr. Archives at the William Way LGBT Community Center helped me find answers to key research questions, as did Sara MacDonald at the University of the Arts. Gonzalo Casals, Noam Parness, and Branden Wallace at the Leslie Lohman Museum of Gay and Lesbian Art in New York opened their collections for review and helped me flesh out my understanding of queer artists in the 1970s and 1980s. Numerous others helped in various ways: Lynne Brown, Harris Fogel, Emmet Gowin, Larry P. Gross, Terry Hourigan, Matt Leifheit, Joan Lyons, Christina Pirello, Kathy Ruyak, Keith Smith, Judith Stein, and Zoe Strauss.

For permission to reproduce works of art in my essay, I thank Micaela Frank at P.P.O.W. Gallery, New York; Victoria Harris at the Ray K. Metzker Archive, Philadelphia; Terry Hourigan; Maureen McLaughlin at Pace/MacGill Gallery, New York; Judith Joy Ross; and Floyd J. Waggaman.

My best conversations about art are with my husband, Virgil Marti, who is loving and supportive in every aspect of my life. He is also a domestic god who had delicious dinners waiting for me whatever time I made it home from the office. Thank you, Sweetie.

Peter Barberie
The Brodsky Curator of Photographs, Alfred Stieglitz Center at the Philadelphia Museum of Art

Published on the occasion of the exhibition *Long Light: Photographs by David Lebe*, Philadelphia Museum of Art, February 9–May 5, 2019

This exhibition was made possible by Lynne and Harold Honickman, The Edna W. Andrade Fund of the Philadelphia Foundation, Barbara B. and Theodore R. Aronson, Emily and Mike Cavanagh, and Arthur M. Kaplan and R. Duane Perry.

Credits as of November 16, 2018

Cover: *Boy Dream*, 1981/89 (detail of plate 27)
Page 140: *Self-Portrait #6, Pissing*, 1977/96 (detail of plate 15)

Produced by the Publishing Department
Philadelphia Museum of Art
Katie Reilly, The William T. Ranney Director of Publishing
2525 Pennsylvania Avenue
Philadelphia, PA 19130-2440 USA
philamuseum.org

Published in association with
Yale University Press
302 Temple Street
P.O. Box 209040
New Haven, CT 06520-9040 USA
yalebooks.com/art

Edited by David Updike
Production by Richard Bonk
Designed by Roy Brooks, Fold Four, Inc.
Separations by Professional Graphics, Inc., Rockford, IL
Printed and bound in Belgium by Die Keure, Brugge

Philadelphia Museum of Art photography by Tim Tiebout except figs. 4 and 16 by Mae Belle Vargas

ISBN 978-0-87633-288-7

Library of Congress Cataloging-in-Publication Data
Names: Barberie, Peter, 1970– author. | Philadelphia Museum of Art, organizer, host institution.
Title: Long light : photographs by David Lebe / Peter Barberie.
Description: Philadelphia, PA : Philadelphia Museum of Art ; New Haven : in association with Yale University Press, 2019. | "Published on the occasion of the exhibition Long Light: Photographs by David Lebe, Philadelphia Museum of Art, February 9–May 5, 2019."
Identifiers: LCCN 2018050362 | ISBN 9780876332887 (hardback)
Subjects: LCSH: Photography, Artistic—Exhibitions. | Lebe, David—Exhibitions. | BISAC: PHOTOGRAPHY / Individual Photographers / Monographs. | PHOTOGRAPHY / Collections, Catalogs, Exhibitions / General. | ART / History / Contemporary (1945–).
Classification: LCC TR647 .L3975 2019 | DDC 770—dc23 LC record available at https://lccn.loc.gov/2018050362